THEN & NOW®

MARIETTA

OPPOSITE: Marietta Square was thriving when this photograph was taken in 1927. Just check out all the stylish automobiles. Only the two buildings at left would survive a disastrous fire five years in the future. (Courtesy of Marietta Museum of History.)

THEN & NOW®

MARIETTA

Joe Kirby and
Damien A. Guarnieri

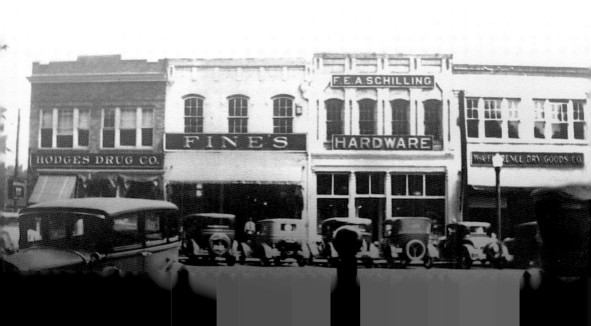

To my father, Joe, and mother, the late Jimmie Kirby, who first instilled in me an appreciation of history; to my wife, Fran, and to our children, Lucy and Miles; and to the readers of the Marietta Daily Journal.
—Joe Kirby

To my wife, Lisa; to my parents, Jack Guarnieri and Lauren Sauer; to my sister Anne-Marie; to the rest of my family and friends; and to my late grandfather Charles Sauer for my first camera.
—Damien A. Guarnieri

Published by Arcadia Publishing
Charleston, South Carolina

Printed in the United States of America

Then and Now is a registered trademark and is used under license from Salamander Books Limited

For all general information contact Arcadia Publishing at:
Telephone 843-853-2070
Fax 843-853-0044
E-mail sales@arcadiapublishing.com
For customer service and orders:
Toll-Free 1-888-313-2665

Visit us on the Internet at www.arcadiapublishing.com

ON THE FRONT COVER: Many of the storefronts have changed since the top picture was taken in 1910. The First Baptist Steeple and Marietta Paper Mill smokestack are long gone, but the view is unmistakably that of Marietta Square. The older image was taken from the steeple of the old Cobb Courthouse, and the modern image from the roof of 10 East Park Square, a county administrative building on the site of the old courthouse. (Then image courtesy of Marietta Museum of History; now image courtesy of Damien A. Guarnieri.)

ON THE BACK COVER: The statue of U.S. Senator Alexander Stephens Clay of Marietta appears to be gazing at the old Cobb Courthouse as it is dismantled in the late 1960s—note the absence of most of the courthouse steeple. The statue was moved in the mid-1980s to its present location on the west side of the square. (Then image courtesy of Marietta Museum of History/Joe McTyre.)

Contents

Acknowledgments vii

Introduction ix

1. The Square 11

2. Along the Tracks 33

3. Church and Cherokee Streets 45

4. Roswell, Washington, and Lawrence 59

5. Fairground Street 73

6. Atlanta and Powder Springs Streets 79

7. Whitlock and Kennesaw Avenues and Polk Street 87

ACKNOWLEDGMENTS

This book would not have been possible without the work of the Marietta and Cobb historians who came before, both professional and amateur. Special thanks must go first of all to Dan Cox and Jan Galt at the Marietta Museum of History, whose assistance proved invaluable. Dr. Tom Scott of Kennesaw State University (KSU) was a vital resource as well, volunteering many photographs from his collection and steering us toward treasures in the KSU Archives.

Marietta Daily Journal publisher Otis A. Brumby Jr. generously let us have our pick of the newspaper's archives, and *Marietta Daily Journal* associate editor Bill Kinney unearthed long-forgotten photographs from his basement for this book. Kinney, whose Cobb newspaper career began in 1938 with the old *Marietta Journal*, was also invaluable in terms of remembering "what was what" in some of these old photographs. Kinney's photograph collection forms a large part of the archive at the Marietta Museum of History, and many of them he took himself with a Speed Graphic camera while working at the Bell Aircraft plant here during World War II and at the old *Cobb County Times*.

Thanks are due as well to retired Marietta photojournalist Joe McTyre, who as a young photographer in the 1950s and 1960s took numerous pictures of downtown Marietta that provide a visual record of downtown as it was on the eve of sweeping changes, and whose photographs, along with those of Kinney, now provide an important part of the collection at the Marietta Museum of History.

We also would be remiss were we to fail to mention Maryellen Higgenbotham at the Root House Museum and Tamara Livingston at the KSU Archives. And thanks as well to Cobb County director of communications Robert Quigley for allowing us on the roofs of the Cobb State Court Building and 10 East Park Square (the gold-windowed building that replaced the courthouse) to try to replicate photographs shot decades ago from the steeple of the old courthouse. Thanks as well to Carolyn Crawford of the Georgia Room of the Cobb-Marietta Public Library.

Unless otherwise noted, the modern images were taken by Damien A. Guarnieri.

INTRODUCTION

Marietta is one of the most dynamic cities of its size anywhere in the South—yet it's also a place where it is not hard at all to mentally roll back the clock 50 years, or 100, or even 150. Downtown Marietta, despite its congestion, despite the modernistic government buildings that dominate the east side of the square, despite the F-22s screaming overhead, has a timeless quality. So do many of its older neighborhoods.

That timelessness is epitomized by the vintage photograph on the cover of this book, taken on a winter day in 1910 from the steeple of the old Cobb Courthouse tower looking north across the square. The facades along North Park Square are almost completely different than today, with the most notable example of that being the Strand Theatre, which has dominated its corner of the square since 1937. The skyline in 1910 is punctuated by smokestacks (the tallest being that of the Marietta Paper Mill), a steeple (First Baptist of Marietta), and a water tower, none of which now exist. But even a newcomer to town would almost instinctively be able to identify the scene as Marietta Square. Part of it is the presence of a gazebo, part of it is the shape of the square, and part of it is the familiar outline of Kennesaw Mountain in the distance (an outline that would be drastically different today had not the Depression fortuitously checkmated a developer's plans to cover its crest with luxury houses).

Even though downtown has continued to evolve, and even though Glover Park in the square has been completely made over several times in its history, there remains an almost tangible continuity there between the past and the present, the "then" and the "now." Scores of freight trains still rumble by each day with regularity only a block from the square, just as they have done since the town's founding concurrent with construction of the Western and Atlantic Railroad. The square and its immediate environs remain the nucleus of the county's governmental and judicial establishment, just as they always have. Retailing is no longer a major factor downtown, but specialty merchants and antique stores have carved a niche that seems set for the long haul. Farmers no longer bring their cotton and produce to the square by mule wagon on Saturdays, but it's a rare weekend these days that there is not a major outdoor festival attracting large crowds.

The chains of memory and architecture that link Marietta with its past are enduring yet fragile. Replacing old buildings with new ones is the natural order of things for every city, yet Marietta allowed an inordinate number of those "links" to be lost in the 1950s, 1960s, and early 1970s. The destruction of the Victorian-era courthouse remains the most tragic and unforgivable, and the building that replaced it continues to be a visual blot on the square. But the demise of the courthouse was just one departure among many. It led the way for the destruction of the entire east side of Marietta Square (including the old jail) and several adjacent blocks, which were replaced by the dispiriting, fortress-style architecture of the county courthouse/judicial complex, as well as what originally were several banks.

Other losses in the grim parade included the old Marietta City Hall (which had been an opera house in an earlier life), the unique county administration building hewn of stone by FDR's Works Progress

Administration crews during the Depression, the Marietta Hospital building on Cherokee Street, the Freight Depot, the Waterman Street School, the Haynes Street School, and the Lemon Street School.

Also eradicated were the magnificent old sanctuary of Marietta First Methodist Church, whose steeple and its near-twin at the courthouse a block away had dominated the city skyline for nearly three quarters of a century; Turner Chapel African Methodist Episcopal Church; and the First Congregational Church, another black house of worship just over the tracks on Whitlock Avenue where Walgreens Pharmacy is today. And even most of the churches that stayed put saw the need to bulldoze numerous nearby old houses to provide adequate parking.

Road-building took its toll as well, as the Marietta Loop gouged through an old neighborhood two blocks west of the railroad, obliterating many houses and causing others to be moved. The antebellum Kennesaw House (now the Marietta Museum of History) and its neighbor, the old passenger depot (now the Marietta Welcome Center), were increasingly decrepit and candidates for demolition, too.

And it was only with great difficulty—via a case that went all the way to the Georgia Supreme Court—that the city was forced to stop whittling away at the square after having paved pieces of it bit by bit for additional parking in the early 1960s.

So by the late 1970s, history and tradition-minded Mariettans felt besieged. At the same time, downtown merchants felt betrayed as longtime patrons began shopping instead at the malls that were springing up. With their collective backs to the wall, local preservation and business interests formed two organizations that have done much to help lay the groundwork of the downtown renaissance of the past quarter century. The first was the Cobb Landmarks and Historic Society; the other, the Downtown Marietta Development Authority. And the most crucial step of all was the successful $1-million campaign led by Mayor Bob Flournoy Jr. in the mid-1980s to renovate and remake Glover Park, which has helped make possible most of the positive things that have happened downtown since then.

Also noteworthy was the creation in the early 1990s of the Marietta Museum of History by Mayor Joe Mack Wilson at the urging of local printer and history buff Dan Cox. Starting out with nothing, Cox—who was essentially ordered by Wilson to become the director of the then-nonexistent museum—has in the space of just 15 years created a gem of a facility that has done much to shift the public's attention back to the city's origins in the 1830s and 1840s as a railroad town and to its rich Civil War history.

This book, then, is meant as a means by which to gaze backward at what we have lost forever, yet at the same time to note that in more than a few cases, the "now" is so much better that no one in his right mind would want to go back to "then."

We hope you enjoy it.

THE SQUARE

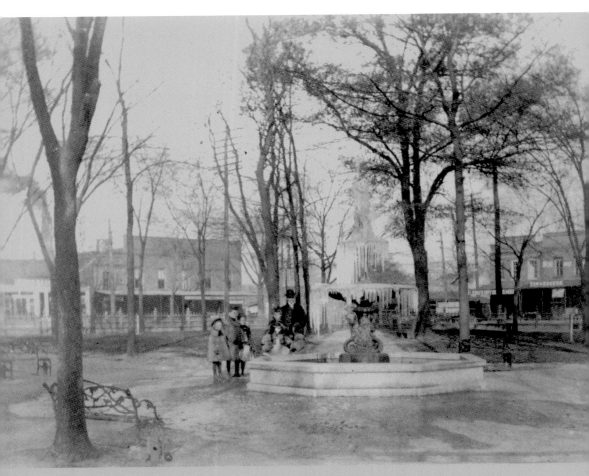

This gentleman and five young girls—his daughters, perhaps—put on their Sunday best to brave the cold and pose by the frozen-over fountain on Marietta Square around 1900. A century later, the square sports fancier landscaping, but other than that, remarkably little has changed. (Courtesy of Marietta Museum of History.)

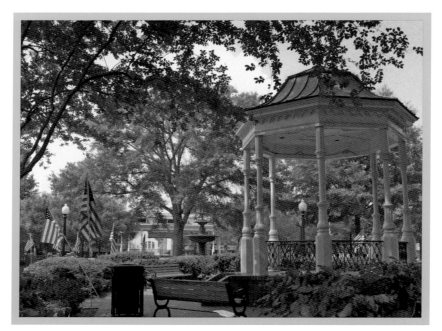

The gazebo above is not the first on the square but was built during the restoration of Glover Park in the mid-1980s. Meanwhile, the remnants of the old gazebo were stored and reconstructed shortly around 2000 in Gov. Joseph M. Brown Park between the Confederate Cemetery and the South Loop. The flagpoles signify the states whose soldiers are buried in the nearby graveyard. (Both images courtesy of Damien A. Guarnieri.)

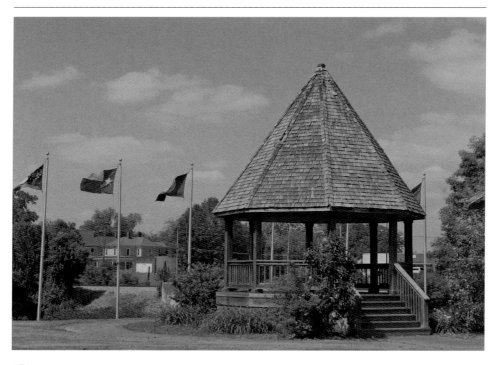

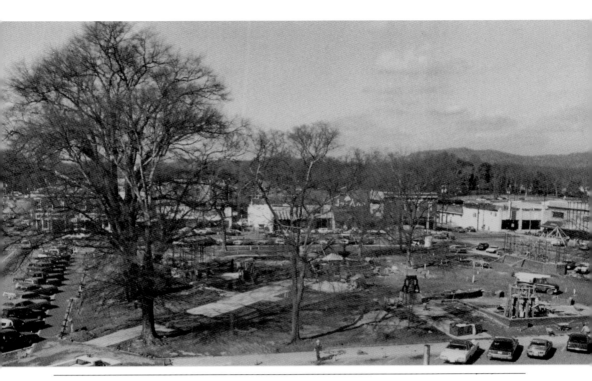

By the 1970s and 1980s, Glover Park in Marietta Square, once the city's showpiece, had a tattered look. Mayor Bob Flournoy Jr. then led a $1-million face-lift of the park that included building a new gazebo and a permanent bandstand, which made the square once again a focal point of life in Marietta. This shot from the east side of the square shows the reconstruction in progress. (Then image courtesy of *Marietta Daily Journal*.)

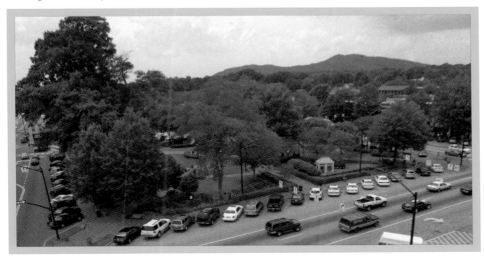

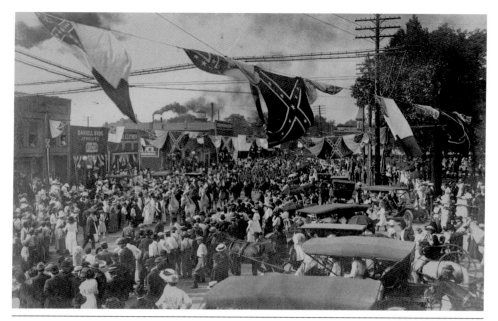

Horsemen, a band, and a military unit led the parade down West Park Square toward the Confederate Cemetery in April 1915 on Confederate Memorial Day before a huge throng. Barely visible at left on the front of Daniell Brothers Jewelers hangs a large portrait of Gen. Robert E. Lee. Marietta still celebrates Confederate Memorial Day, as seen in this parade shot from 2001 featuring the late governor Lester Maddox of east Cobb. (Then image courtesy of Marietta Museum of History; now image courtesy of *Marietta Daily Journal/* Damien A. Guarnieri.)

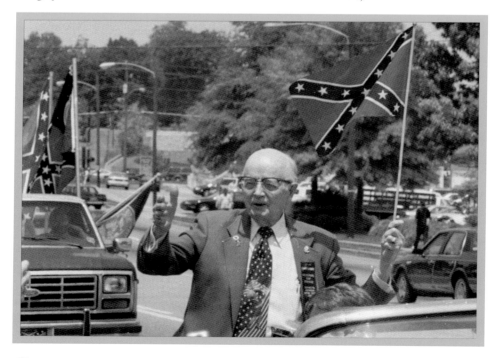

Want to draw a crowd? Then give something away. In this case, the W. A. Florence Department Store on North Park Square was giving away a diamond ring worth $100 in 1914—and no doubt worth thousands in today's dollars. Florence's gave way long ago to restaurants and the Strand Theatre. (Then image courtesy of Marietta Museum of History.)

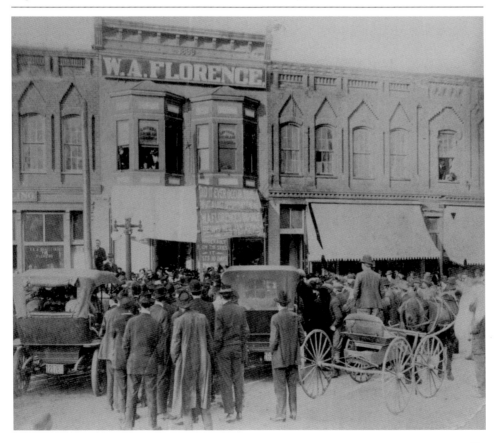

A faulty heater in the Najjar Department Store sparked the blaze that damaged or destroyed most of the northeast side of the square during a howling gale early on Halloween morning 1932. The ruins stood vacant for five years until construction of the Strand Theatre in 1937, now owned by the Goldstein family and slated for renovation. Note the old-time traffic signal in the center of the nearby intersection. (Then image courtesy of Marietta Museum of History.)

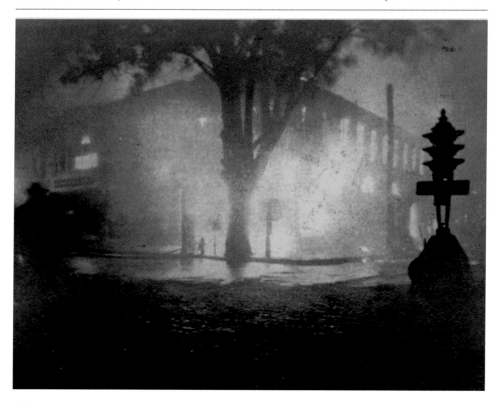

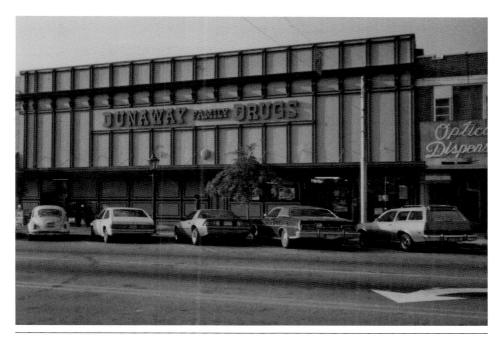

Dunaway Drugs, seen here in 1984, was a fixture on the north side of Marietta Square from the 1940s to the late 1980s, when future mayor Bill Dunaway sold it to the Eckerd chain. Dunaway was the first of Marietta's downtown lunch counters to integrate in the 1960s. Since 2000, the property has been renovated and now is home to two of the square's most popular eateries. (Then image courtesy of Dr. Tom Scott.)

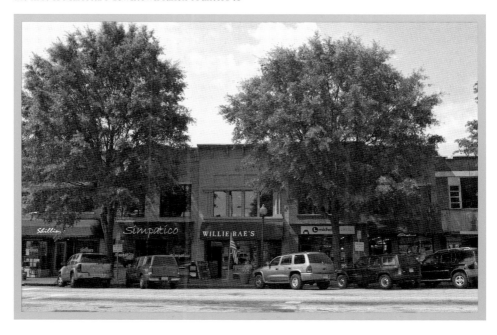

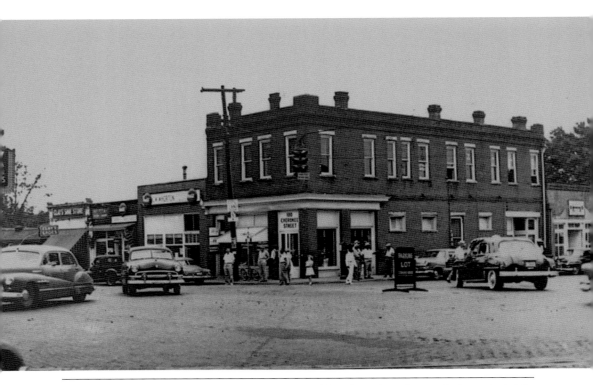

"Nondescript, but busy" best summed up how the North Park Square/Lawrence Street corner facing the square looked in the late 1940s. Sixty years later, that corner is the nerve center of Cobb government, the main county administration building, housed in what was built as a bank. The buildings seen in the older picture were bulldozed in the early 1970s. (Then image courtesy of Marietta Museum of History.)

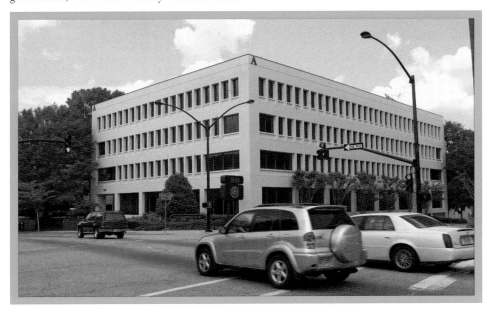

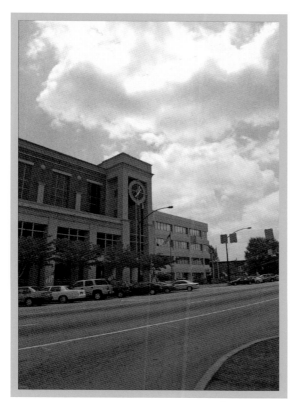

Frank Rogers's grocery next to the courthouse was notable for its dance hall on the second floor and the fact it was black-owned. His store sported a Coca-Cola advertisement on the wall in this 1910 photograph and was well known enough to be mentioned by civil rights activist W. E. B. DuBois in one of his books. Rogers's brother, Andrew Rogers, operated a barbershop in the Masonic Lodge on South Park Square. (Then image courtesy of Marietta Museum of History.)

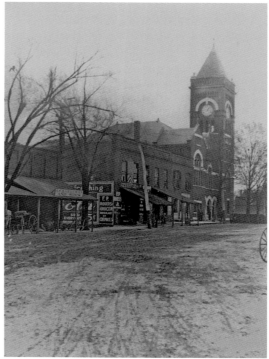

Parks Groover is seen here in the doorway of Groover's General Store with his son, Joe, in 1885 at the corner of what is today Atlanta Street and Roswell Street. Later a hardware store, the business was kept in the Groover family until 1972. Operating in the same building, Tommy's sandwich shop has been a fixture on the square for decades. (Then image courtesy of Vanishing Georgia Collection, Georgia Department of Archives and History.)

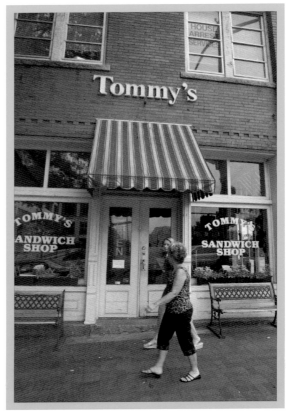

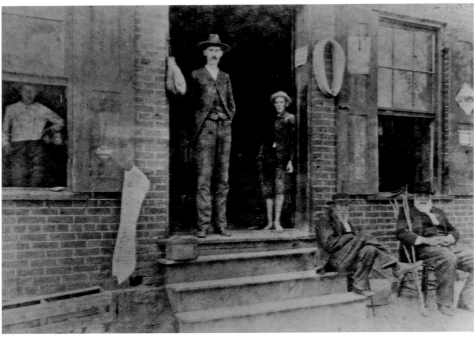

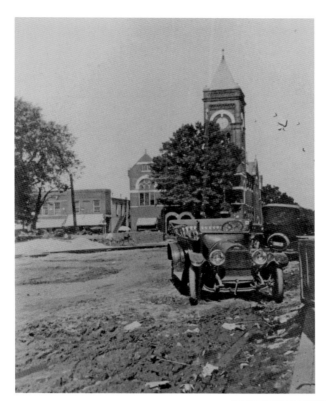

A sea of dust when dry, an ocean of mud when wet—here is a final view of the square in 1917 just before its streets were paved. In the background are a pile of sand and a worker. Note the hand crank on the front of the car in the foreground. (Then image courtesy of Marietta Museum of History.)

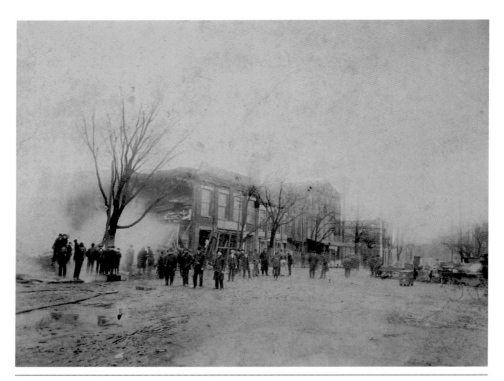

This 1900 fire nearly gutted the building that now houses Le Peep restaurant at the corner of South Park Square and Winters Street. Building contents that were rescued from the blaze can be seen piled in the street, a common practice in those days when there was a fire—and little traffic to worry about. The taller building down the block is the Masonic Lodge. (Then image courtesy of Marietta Museum of History.)

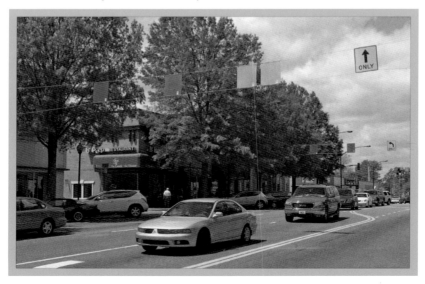

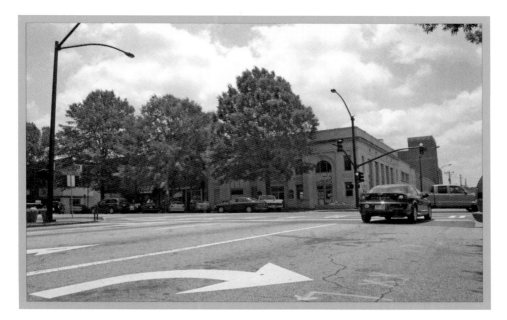

The Masonic Lodge overlooking Marietta Square, pictured in the 1900s sporting a "Tuxedo Tobacco" advertisement on the wall facing Powder Springs Street, was one of about 80 buildings in town that General Sherman failed to burn. It was demolished in the 1910s for the First National Bank building, which still stands. The two men with backs to the camera likely were cotton buyers, as the street is full of cotton farmers. (Then image courtesy of Marietta Museum of History.)

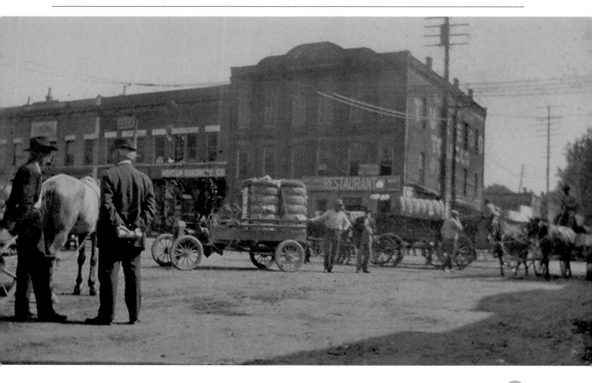

The Cobb County Courthouse was burned by Sherman's cavalry in November 1864. Its columns—"Sherman's sentinels"—were all that remained and cast a pall over the square for nearly a decade. The county was so devastated by the war that it was not until 1872 that it could afford to erect a replacement, on the same site. (Then image courtesy of Marietta Museum of History.)

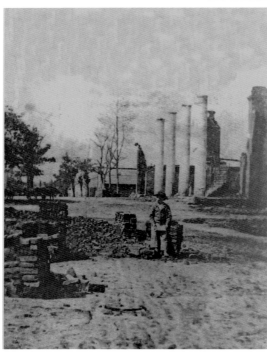

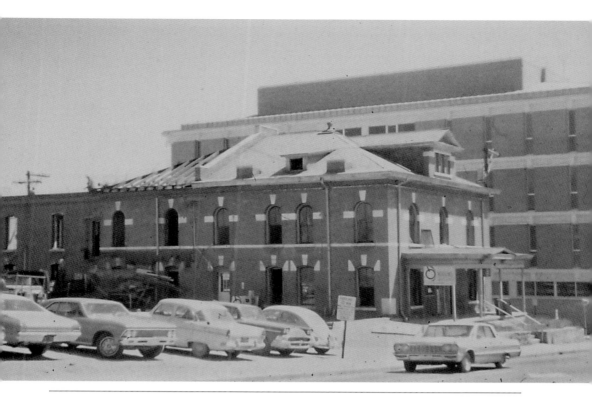

The Cobb jail is seen as it was readied for demolition in 1969. It stood directly behind the courthouse on the same block and was torn down at the same time. Although both buildings were outmoded and overcrowded, both could have been saved. The loss of the courthouse, in particular, is still much lamented, particularly in light of the garish gold-windowed appearance of its replacement. (Then image courtesy of Ernest Wester Collection, Kennesaw State University Archives.)

Young Marietta photographer Joe McTyre took a quartet of panoramic views from the old courthouse tower in the early 1960s. In this shot, looking east up Roswell Street, one sees the curved roof of the old Greyhound Bus station, now converted into law offices. The modern photograph, snapped from the roof on the county administration building on almost the same spot, shows comparatively little change. (Then image courtesy of Joe McTyre.)

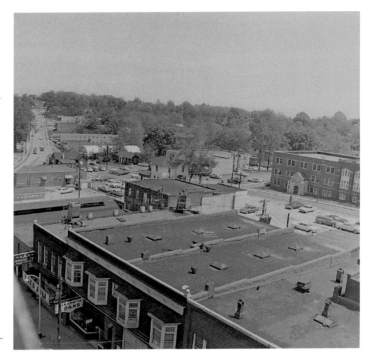

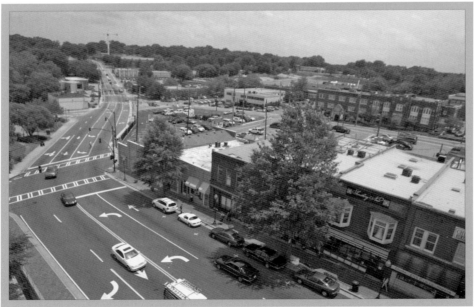

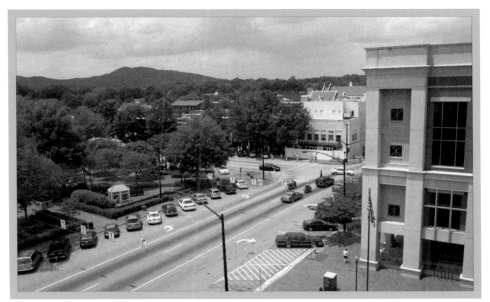

Looking north from atop the courthouse, one sees the Strand Theatre, still going strong in those pre-multiplex days. On the edge of the square is a playground, a forerunner of the playground there today. At right in the current picture is the State Court Building, built in the mid-1990s. (Then image courtesy of Joe McTyre.)

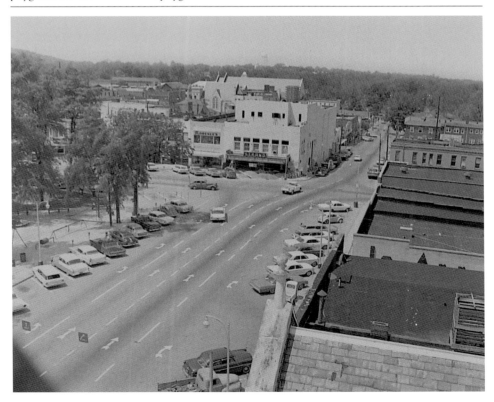

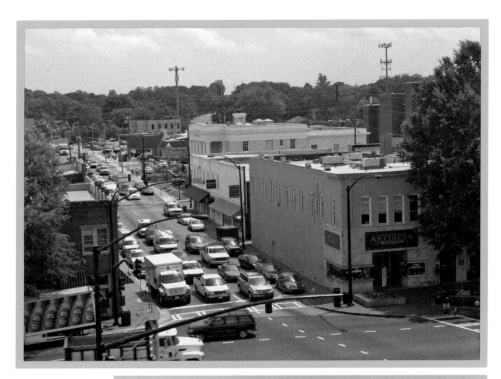

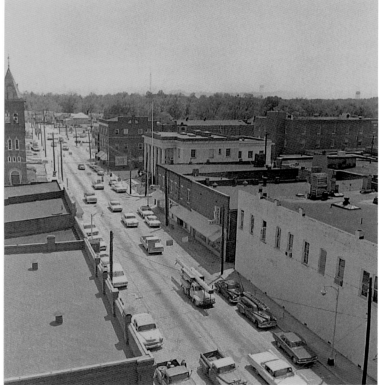

Were it not for the old post office building at right, now the Marietta/ Cobb Museum of Art, Atlanta Street would be almost unrecognizable today. Gone are the First Methodist Church at left and, just beyond the post office, the old Marietta City Hall. In their place are parking lots. (Then image courtesy of Joe McTyre.)

Even more unrecognizable today is the 1960s view looking northeast from the courthouse. Gone are, from left to right, Turner Chapel AME, the first block of buildings on the south side of Lawrence Street, and the Depression-era stone-sided county building. Nearly hidden is the scalloped facade of the old Cobb Federal Savings and Loan. Today's view is dominated by the 1970s-vintage Cobb Superior Court Building. (Then image courtesy of Joe McTyre.)

A natural-gas explosion ripped through the Atherton Drug Store on the southwest corner of Marietta Square on Halloween night of 1963. Six people were killed, and the interior of the structure was gutted by the blast, which was forceful enough to twist the Whitlock Avenue street sign out front. (Then image courtesy of Marietta Museum of History.)

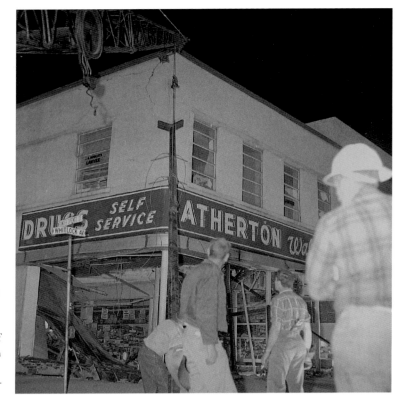

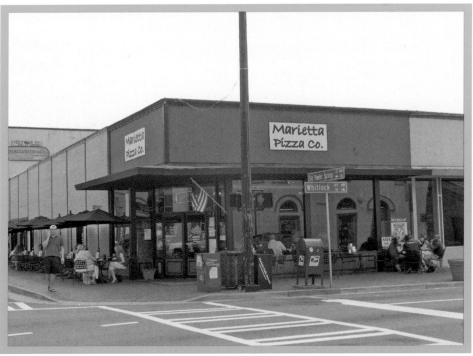

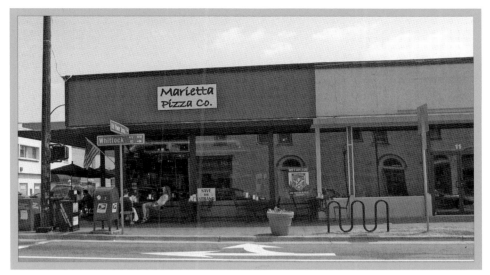

Its upper floor now removed and its distinctive blonde bricks now covered with siding for the most part, the old Atherton Drugs building has housed eateries in recent years. Chicago Hot Dogs—with its distinctive facade—was a fixture in the 1980s and 1990s, and in recent years, Marietta Pizza has helped bring sidewalk dining to the square. (Then image courtesy of Dr. Tom Scott.)

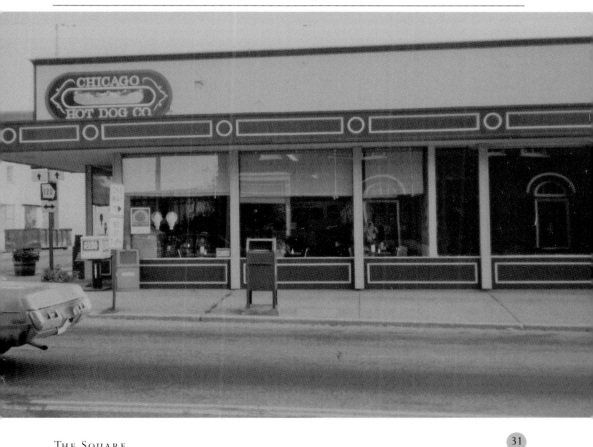

The widely acclaimed Theatre in the Square got its start in 1984 in the old Marietta Depot restaurant—dig the 1970s–style lettering on the eatery's sign—on Polk Street, a half-block off the square and a block north of its current location on Whitlock Avenue. Its first home now houses a coffee shop and a pet-care store. (Then image courtesy of Dr. Tom Scott.)

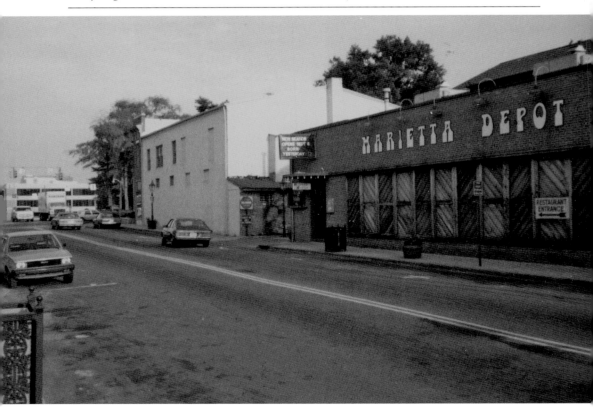

CHAPTER 2

ALONG THE TRACKS

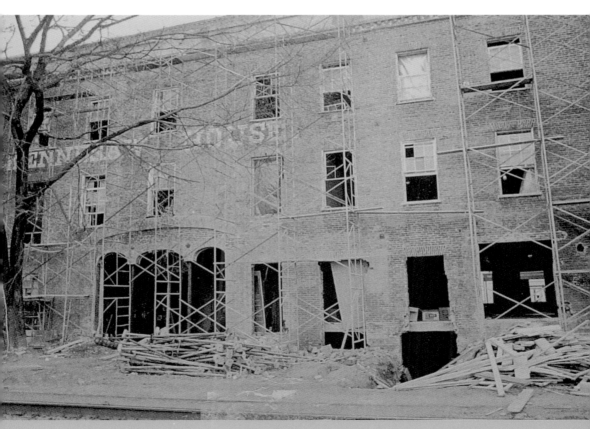

A parapsychologist hired by the History Channel once said there were 1,000 ghosts at the Kennesaw House—and it looks entirely possible based on this picture snapped during its early-1980s renovation. (Courtesy of Marietta Museum of History.)

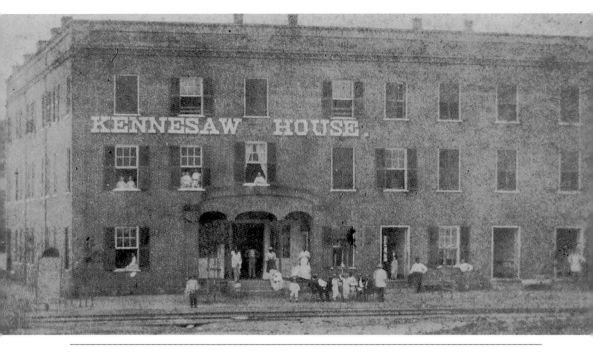

Most of Andrews' Raiders slept in the Kennesaw House (seen here in 1867) on the night before the 1862 "The Great Locomotive Chase," and the hotel was briefly a headquarters for Gen. William T. Sherman. Its fourth floor burned during the war and was never rebuilt. A comparison of the two photographs shows the level of the sidewalk out front was raised through the years. (Then image courtesy of Marietta Museum of History.)

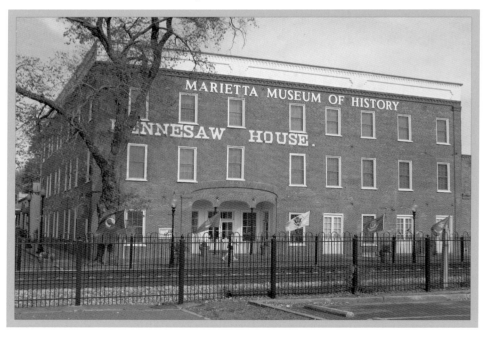

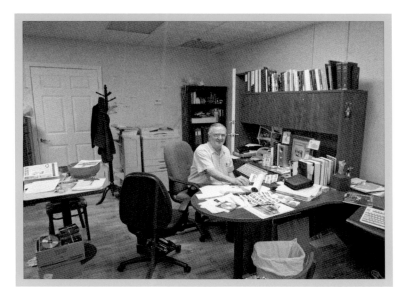

Among the amenities at the Kennesaw House was the rooftop garden on its terrace level on the Depot Street side of the building, seen here in 1913. Its attractions included orange trees, which would be moved inside during cold weather. The terrace was later enclosed as office space during the renovations of the 1970s, and it is now the office of Marietta Museum of History CEO/founder Dan Cox, pictured here. (Then image courtesy of Marietta Museum of History.)

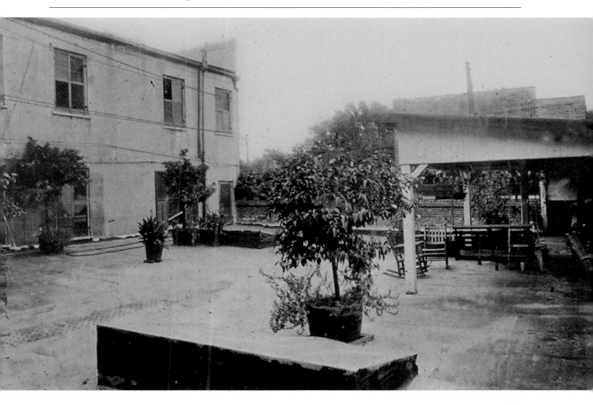

The Glover Machine Works built more than 200 train engines at its Marietta plant in the first decades of the 20th century. The company began as a tool-and-die operation in this shop along the railroad tracks just south of Whitlock Avenue behind today's Walgreens Pharmacy, where this snapshot of a traveling livestock auction was taken around 1910. Note how livestock is on a flatbed railroad car. (Then image courtesy of Marietta Museum of History.)

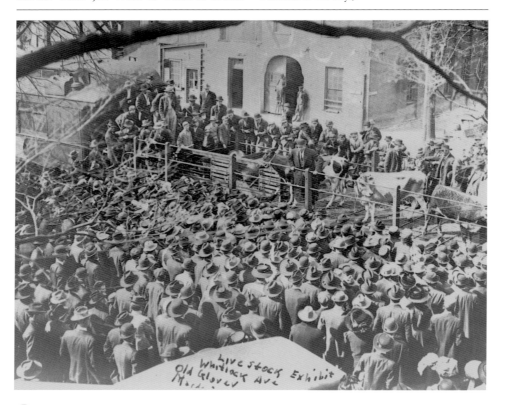

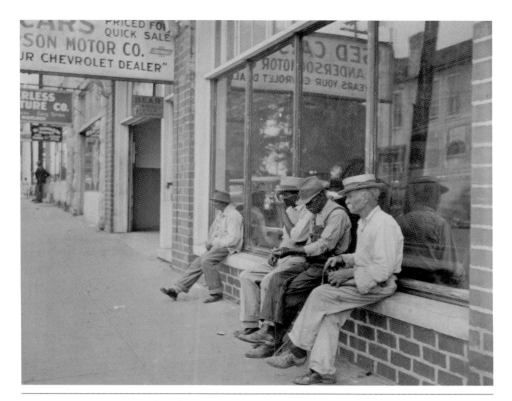

Downtown Marietta was the place to be on Saturday afternoons in Cobb County for most of its history, even if you had nothing to do. These old-timers were whiling away the day outside the Anderson Motor Company on Whitlock Avenue, which today is home to Theatre on the Square. (Then image courtesy of Bill Kinney.)

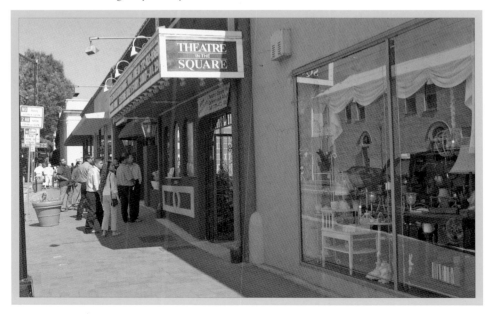

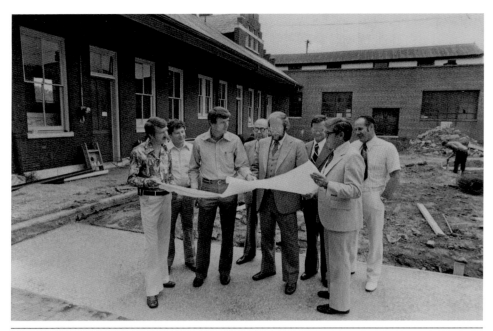

The courtyard behind the old passenger terminal (today's Marietta Welcome Center) was a parking lot by the 1970s, but it was renovated and renamed for Mayor Harold "Red" Atherton and today is a popular place for coffee or an al fresco lunch. Looking at plans were, from left to right, unidentified, Frank Leiter, unidentified, future mayor Joe Mack Wilson (wearing glasses at rear), two unidentified, Southern Bell manager Mack Henderson, and Mayor Dana Eastham. (Then image courtesy of *Marietta Daily Journal*.)

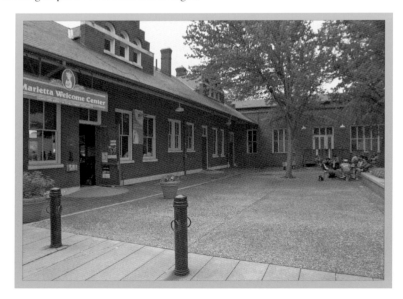

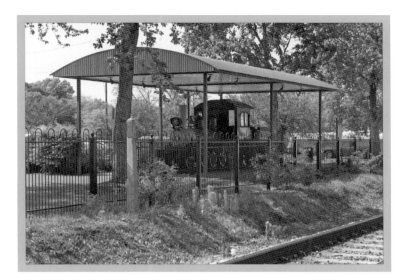

Marietta was a regular stop for traveling circuses, like the one seen here that included a dancing bear. This shot was taken about 1910 in front of the old freight depot, which was demolished after being damaged during a train derailment in the early 1970s. In its place today is a restored locomotive, manufactured a mile south nearly a century ago at the old Glover Locomotive Factory. (Then image courtesy of Vanishing Georgia Collection, Georgia Department of Archives and History.)

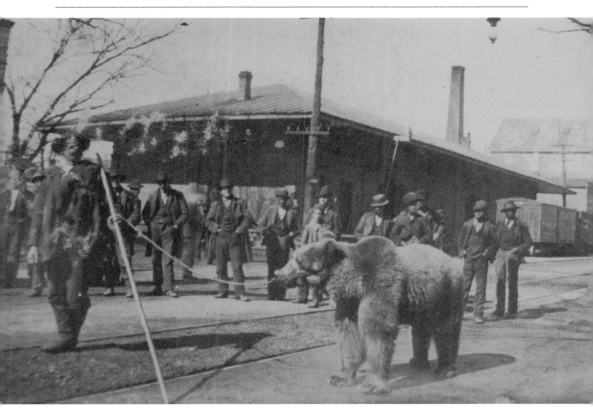

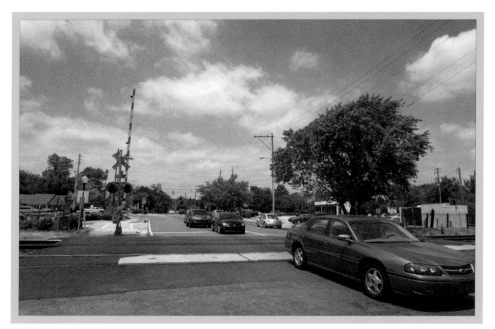

Anderson Livery Stable, on Whitlock Avenue just west of the tracks, was the "Hertz Rent-a-Car" of its era. At rear is a 5,000-gallon water tower. In the carriage at left in the derby hat is local hotelier Milledge Whitlock. In the buggy at right is J. A. G. Anderson. In the distance are a picket fence and large house on a hill in the background—all now gone. The site now is a Krystal restaurant. (Then image courtesy of Marietta Museum of History.)

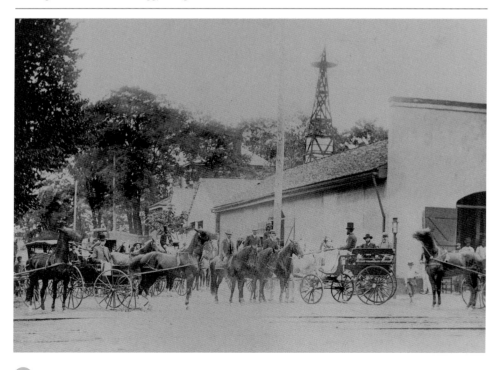

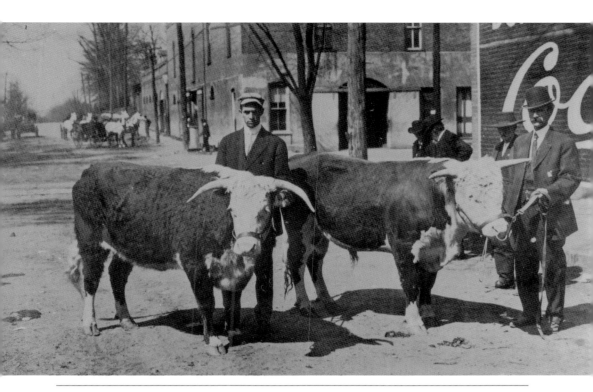

At right in the derby is J. T. Anderson Sr. of Anderson Livery. These steers may have been part of the traveling livestock auction depicted elsewhere in this chapter. This photograph most likely was taken just east up Whitlock Avenue from the Anderson Livery photograph from 1888. A second floor has been added to the stable. And the building with the Coca-Cola sign is today's Gone With the Wind Museum. (Then image courtesy of Vanishing Georgia Collection, Georgia Department of Archives and History.)

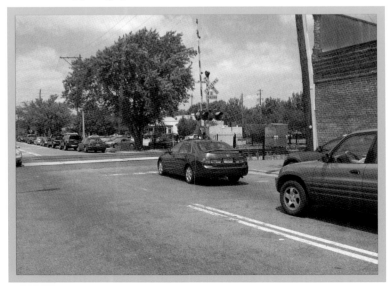

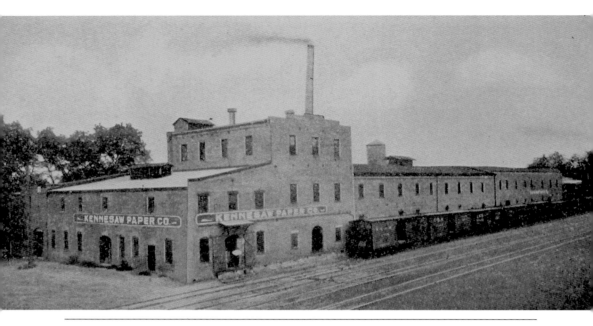

The Kennesaw Flour Mill, later the Marietta Paper Mill, was built by Edward Denmead in 1857 along the Western and Atlantic Railroad tracks on Mill Street. The plant was bought by Saxford Anderson in 1894, who moved part of his papermaking operation there from Sope Creek in east Cobb and began producing 10,000 pounds of white paper per day. Like many other early Cobb landmarks, it is now a parking lot. (Then image courtesy of Marietta Museum of History.)

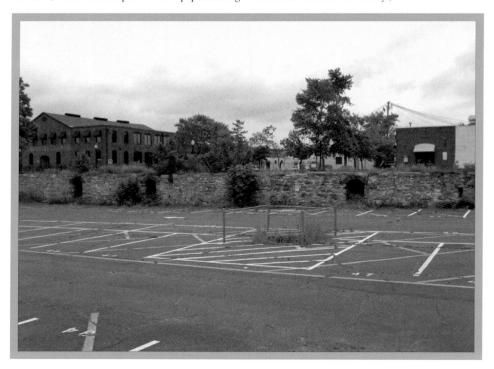

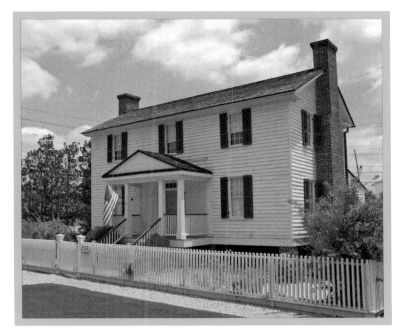

The core of the William Root House, among Marietta's oldest, was built facing the square about 1845, later rolled on logs to the corner of Church and Lemon and enlarged, and, in the 1890s, rolled a half block down Lemon to make way for the Clarke Library. In 1990, the decaying house was moved to Polk Street and the Loop, where the Cobb Landmarks Society operates it as a museum. (Then image courtesy of *Marietta Daily Journal/* Barry Shapiro.)

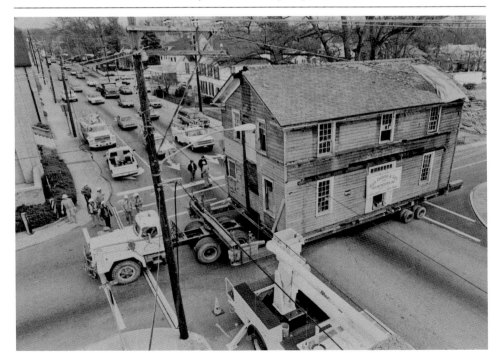

The first Coca-Cola bottling plant in Marietta was on Husk Street, where this photograph was snapped about 1910. The Coke plant is long gone and so is Husk Street, having been swallowed up by construction of the Marietta Loop in the 1980s. The old Coke plant sat on what today would be the edge of the parking lot of the First United Methodist Church of Marietta. (Then image courtesy of Marietta Museum of History.)

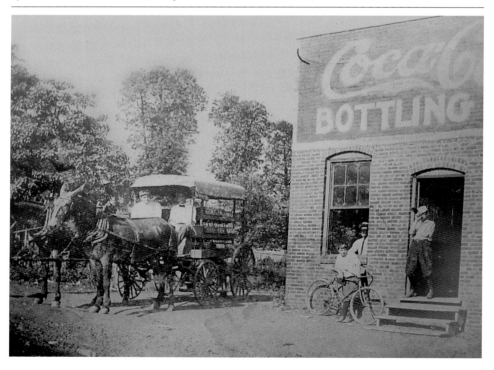

CHAPTER 3

CHURCH AND CHEROKEE STREETS

The first house on this Cherokee Street site was built in 1843 by Edward Denmead. Rebuilt after a fire in the early 1900s it was home to James T. Carmichael, manager of the huge Bell Aircraft Plant in Marietta during World War II, and later to media mogul and Atlanta Falcons part-owner Tom Watson Brown. (Then image Marietta Museum of History.)

A rare heavy snowstorm left Church Street under a shroud of white in this scene snapped prior to the 1905 renovation of First Presbyterian Church. Although just a few blocks from Marietta Square, the street appears to still retain its residential character. A summer shot in the same location today shows that once again, parking lots have triumphed over what came before. (Then image courtesy of Marietta Museum of History.)

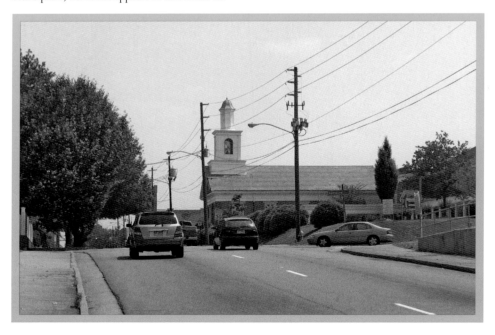

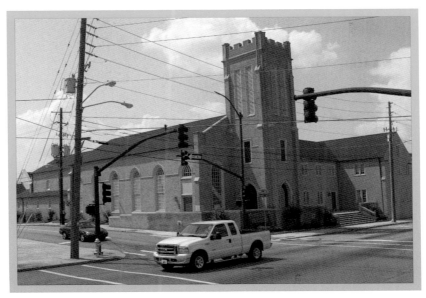

St. James Episcopal on Church Street survived the depredations of Union soldiers during the Civil War only to be gutted by a fire that broke out in the boiler room in January 1964. However, the sanctuary was rebuilt according to the original architectural drawings and rededicated in January 1966. (Then image courtesy of Marietta Museum of History.)

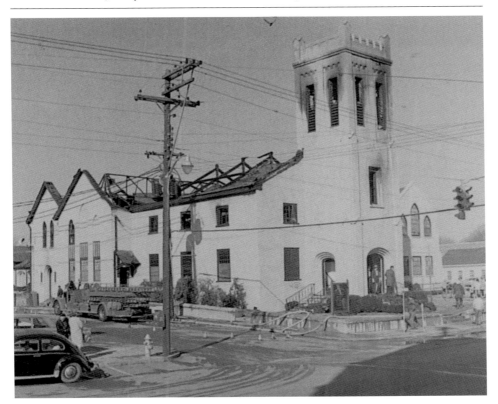

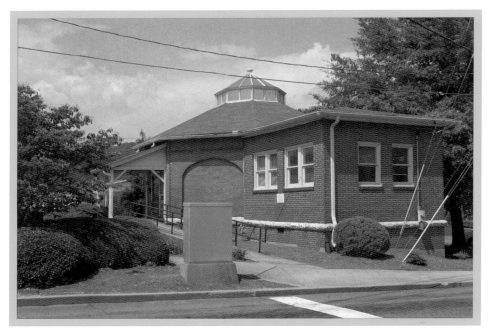

The octagonal Clarke Library was built in 1893 on the site of the William Root House, which was rolled on logs down Lemon Street to make way for it. It was modeled on the cupola of the Reading Room of the British Library in London, and among those who donated to its construction were Oliver Wendell Holmes and Helen Keller. (Then image courtesy of Marietta Museum of History.)

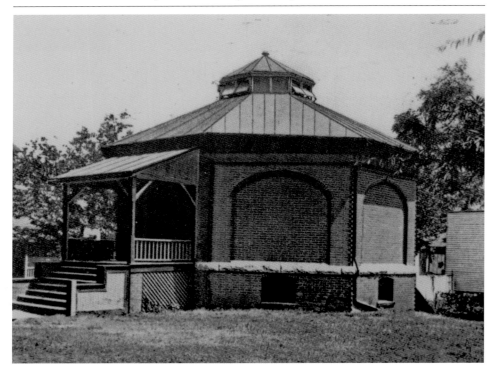

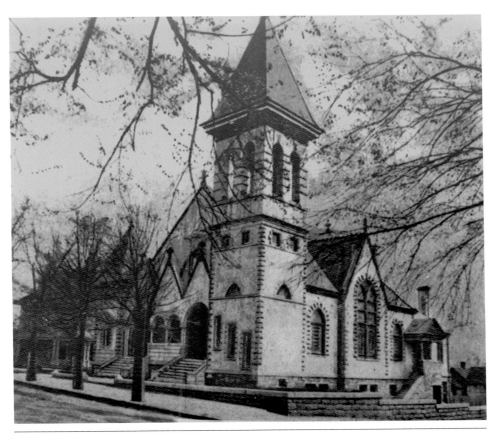

First Baptist of Marietta moved into this Romanesque-style structure in 1897 built on land on Church Street donated by Gov. Joseph M. Brown of Marietta. Seen here in the 1930s, it has been used as a chapel since the construction of a new sanctuary in 1962. Its deteriorating steeple was replaced the same year. (Then image courtesy of Marietta Museum of History.)

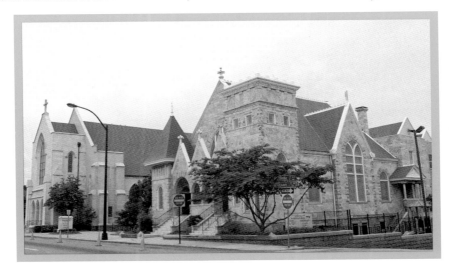

The nucleus of this shabby house once owned by Marietta's first druggist, William Root, was built facing the west side of the square in 1845, then rolled on logs twice before winding up here on Lemon Street. When facing demolition in 1990, it was donated to the Cobb Landmarks Society, which moved it to the corner of Polk Street and the Loop, restored it, and operates it as a museum. (Then image courtesy of Root House Museum/ Joe McTyre.)

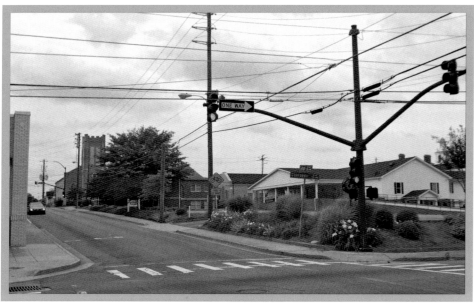

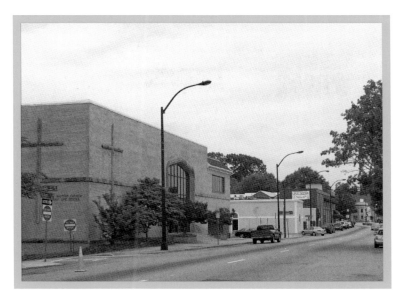

Judging from the traffic on Church Street, it's a Saturday afternoon in the 1940s. Field Furniture was a major retailer. Upstairs was the Georgia Hotel. The hotel had a prime location, as Church Street doubled in those pre-interstate days as U.S. Highway 41, the major connector between Chicago and Florida. Field later moved to Cobb Parkway, and First Baptist's family life center now dominates that side of the street. (Then image courtesy of Bill Kinney.)

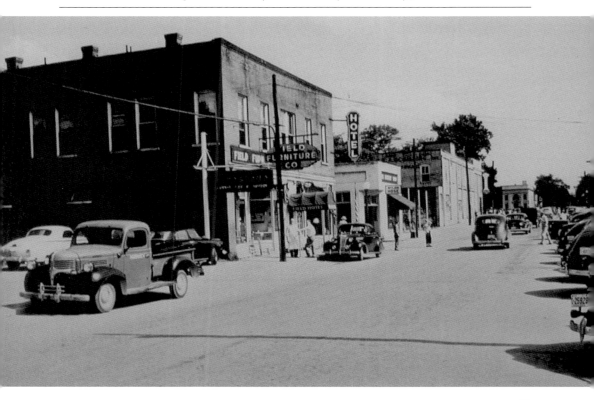

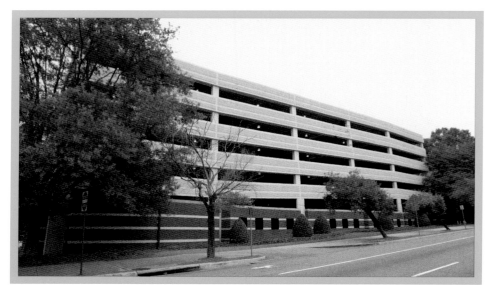

The town gained a first-class medical facility for its era when the 50-bed Marietta Hospital opened on Cherokee Street just north of the square in 1928. But it was soon outmatched by the city's explosive growth during World War II and was replaced by the publicly funded Kennestone Hospital in 1950. The county parking deck now stands on the site of the old hospital. (Then image courtesy of Bill Kinney.)

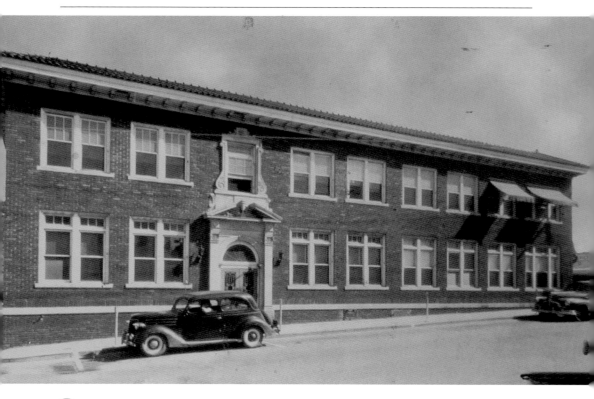

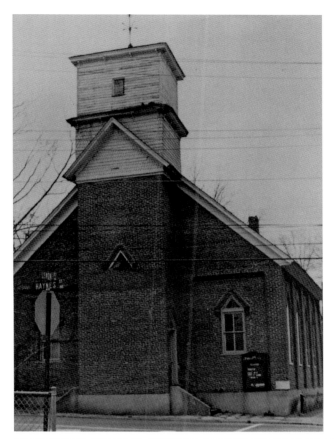

Zion Baptist Church was founded in 1866 by former slaves who had been members of First Baptist of Marietta. Zion built a replacement sanctuary in the 1980s and, as the congregation continued to swell, dedicated an even larger, $13-million home at Cherokee and Lemon in 2007. But the earlier sanctuaries continue in use as well (as seen to the right in the distance of the modern photograph). (Then image courtesy of Marietta Museum of History.)

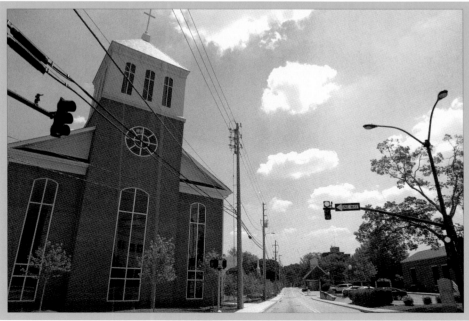

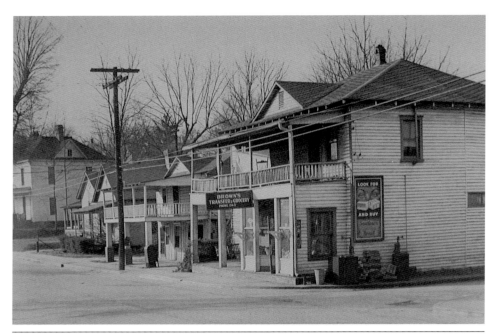

The Cherokee/Page Street intersection was a quiet one in the 1940s. It is no longer. Page Street became part of Marietta Parkway ("The Loop") in the 1980s, and Cherokee was widened and made one way. The Cobb police headquarters was built across the street. Brown's Grocery and all its neighbors are long gone, replaced by a parking lot. (Then image courtesy of Bill Kinney.)

CHURCH AND CHEROKEE STREETS

St. Joseph's is the "mother church" of five other Catholic churches in Cobb and was founded in 1907. After originally meeting on Atlanta Street and later in the building seen in this 1940s vintage shot on Church Street (later demolished for the North Loop), it moved into its present home atop Campbell Hill adjacent to WellStar Kennestone Hospital in 1991. (Then image courtesy of Marietta Museum of History.)

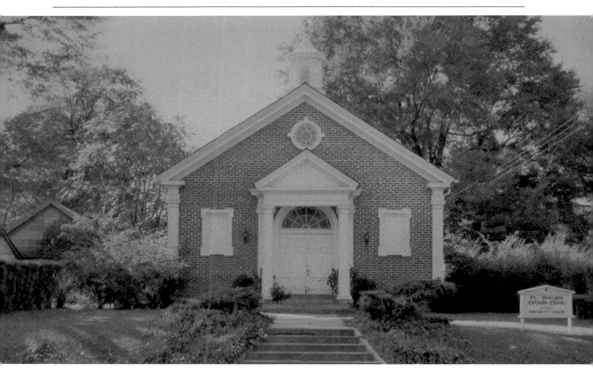

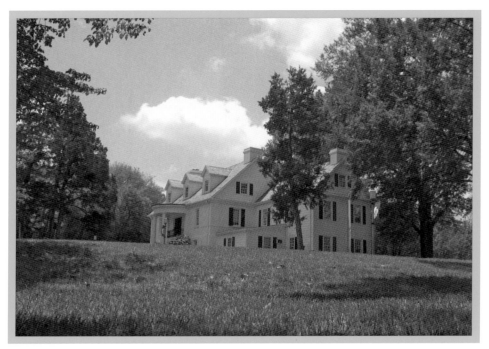

The Kennestone Hospital area was originally known as Campbell Hill after John Campbell, who built this house in 1852, saw it gutted during the Battle of Kennesaw Mountain, then restored it and added a third floor. Later known as Sugar Hill, the house was sold with 22 acres in 1938 to Robert C. Suhr, who renovated and enlarged it and eventually sold it in 1952 to St. Joseph's Catholic Church. (Then image courtesy of Marietta Museum of History.)

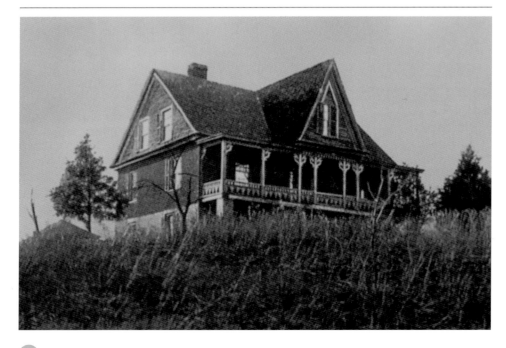

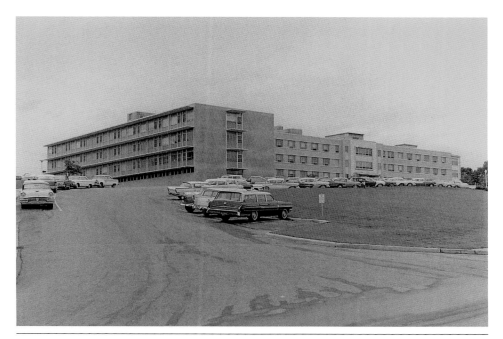

What is now WellStar Kennestone Hospital opened in 1950 atop Campbell Hill and took its name from the fact that on a clear day (in that pre-smog era) one could see both Kennesaw and Stone Mountains from its location. After nearly 60 years of additions and alterations, almost none of the original hospital building remains, but in its place stands one of Georgia's premier health-care facilities. (Then image courtesy of Marietta Museum of History.)

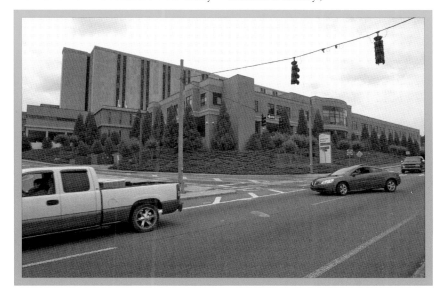

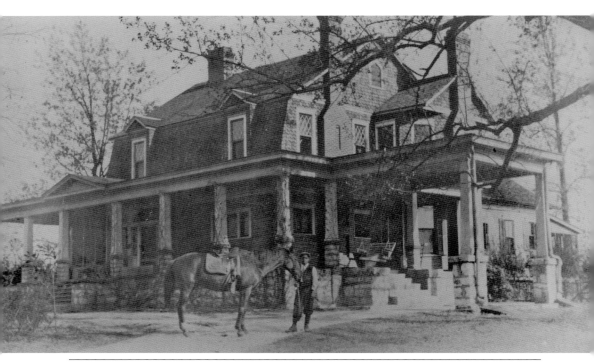

The appearance of this house has changed little since its construction at the corner of Cole and Page (now North Marietta Parkway) Streets in 1908 by DeWitt Clinton Cole, grandson of Henry Greene Cole, who donated the land for the Marietta National Cemetery. The house foundation is of the same stone as the front gate of the cemetery and was quarried near Chickamauga. The house remains in the Cole family. (Then image courtesy of Vanishing Georgia Collection, Georgia Department of Archives and History.)

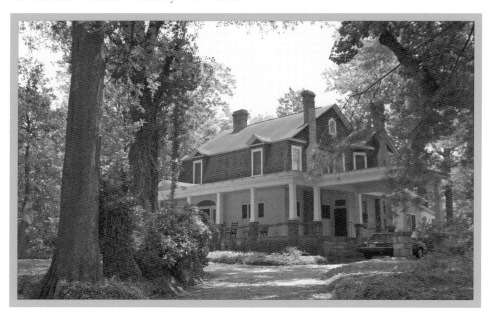

4

ROSWELL, WASHINGTON, AND LAWRENCE

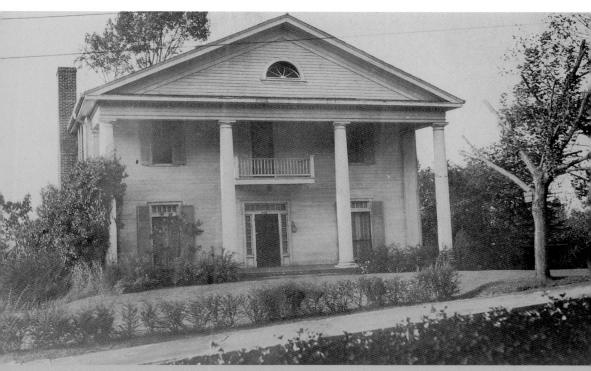

Henry Greene Cole acquired this house, seen in 1940, soon after its completion in the 1840s. The Union-sympathizing Cole was arrested for spying but released. He later donated 26 acres for what now is the Marietta National Cemetery and is buried there. His house today is a law office. (Courtesy of Marietta Museum of History.)

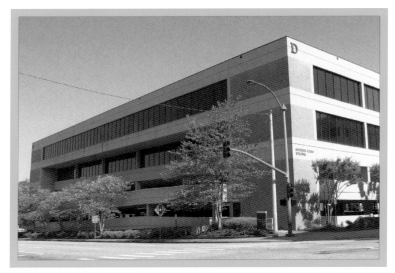

This stone building on Lawrence Street was where most of the government business of Cobb County took place between the 1930s and late 1960s. Built by the Works Progress Administration during the Depression of rock excavated and broken by convicts on county chain gangs as they built local roads, it was a victim of urban renewal three decades later and was replaced with the Cobb Superior Court Building. (Then image courtesy of Bill Kinney.)

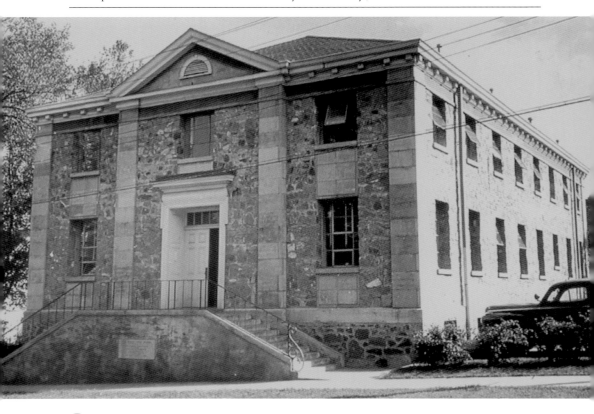

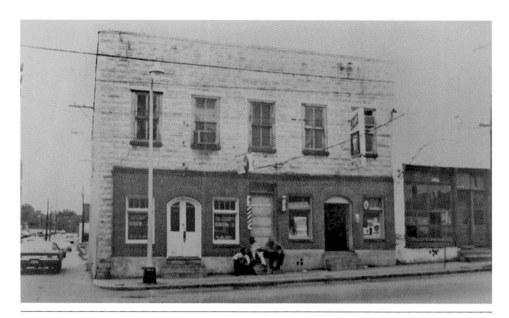

The hub of black commercial life in Marietta during segregation was the first block of Lawrence Street off the square. This building owned by Sylvester "Shine" Fowler boasted a bonding company, funeral parlor, pool hall, restaurant, and taxi service. Upstairs was a black Masonic Lodge. The block was bulldozed in the early 1970s. This portion then spent two decades as a parking lot until construction of the new State Court Building in the 1990s. (Then image courtesy of Marietta Museum of History.)

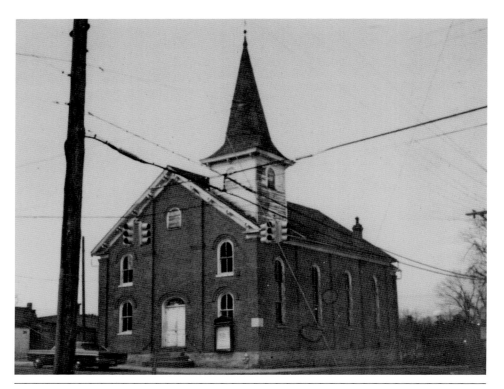

What is now the Turner Chapel African Methodist Episcopal Church first met in a log cabin, then from 1839 until 1974 worshipped at the corner of Lawrence and Waddell Streets a block off Marietta Square. The old sanctuary seen here dated to 1891.

The congregation moved into a new cathedral-style, 3,000-seat sanctuary on North Marietta Parkway in 2005. (Then image courtesy of Dr. Tom Scott/KSU.)

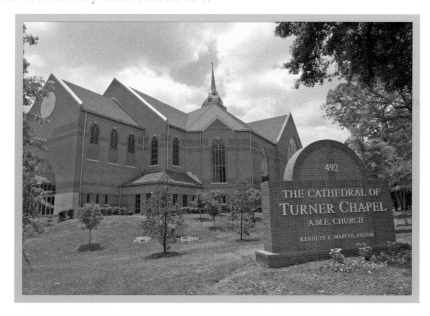

The Marietta police headquarters was state of the art when it opened in 1960. It was crowded and outmoded by the late 1980s, and its top-floor jail was derided by the then-chief as "right out of *Cool Hand Luke*." It was bulldozed and replaced with a park in the late 1990s as part of the makeover of the city hall complex. (Then image courtesy of *Marietta Daily Journal*.)

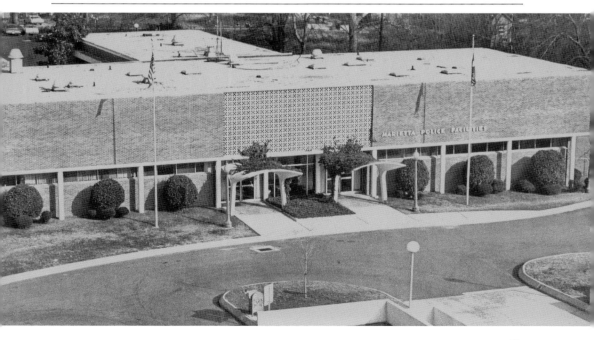

The Haynes Street School opened in 1913, serving as both the elementary for the north side of town and the high school for all students. It also housed school system headquarters in the early years. It later was renamed Keith Grammar School after a former superintendent before being demolished to make way for the Marietta Fire Department headquarters. (Then image courtesy of Marietta Museum of History.)

ROSWELL, WASHINGTON, AND LAWRENCE

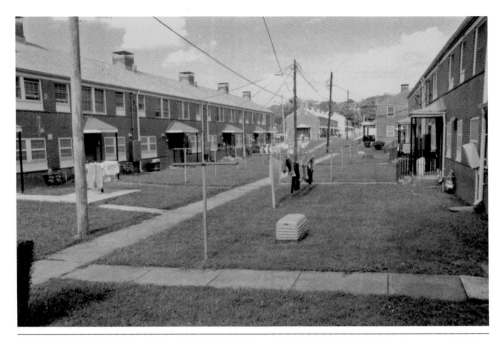

The 132-unit Clay Homes just off Roswell Street (named for U.S. Senator Alexander Stephens Clay of Marietta) and Atlanta's Techwood Homes were the first two public housing projects in the country and opened in 1940. Clay Homes was demolished around 2005 to make way for the mixed-use Meeting Park development, which is to feature 159 condominiums and 130 townhomes. (Then image courtesy of *Marietta Daily Journal/* Bret Gerbe.)

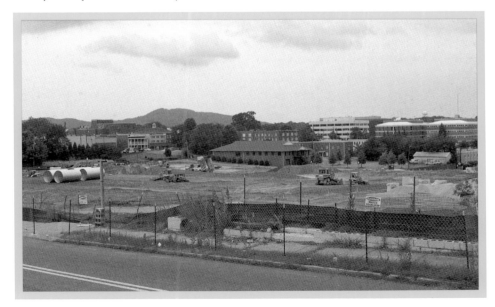

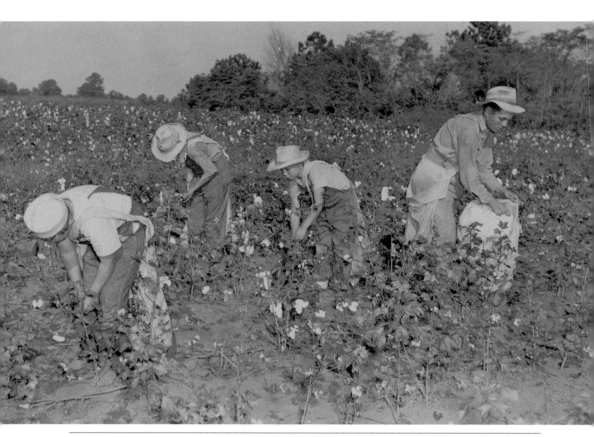

The Town and Country Shopping Center on Roswell Road was one of the city's first suburban strip shopping centers when it opened in the 1950s. Before that, the site was used for growing cotton, as this photograph from the early 1940s attests, and then as an early dirt-strip airfield. (Then image courtesy of Bill Kinney.)

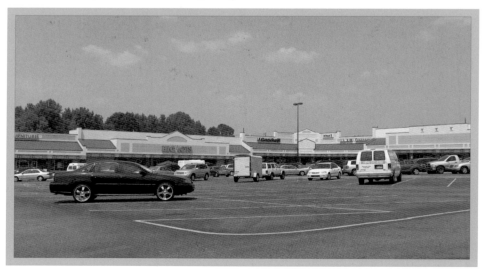

Roswell, Washington, and Lawrence

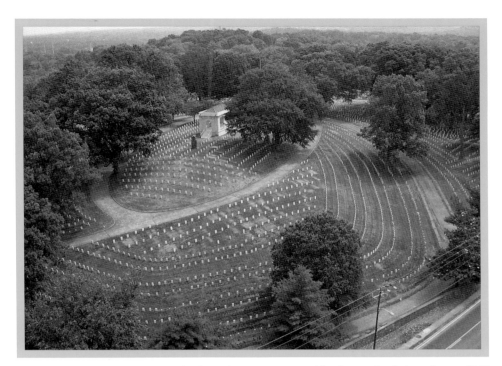

Most Civil War dead were buried where they fell, but by 1870, the remains of 10,171 Union troops—more than 3,000 of them unknown—had been reburied in what is now Marietta National Cemetery, seen here around 1900. They have been joined by thousands of dead from later wars, as suggested by the overhead shot taken in 2007 from a nearby construction crane. (Then image courtesy of Vanishing Georgia Collection, Georgia Department of Archives and History; now image courtesy of *Marietta Daily Journal*.)

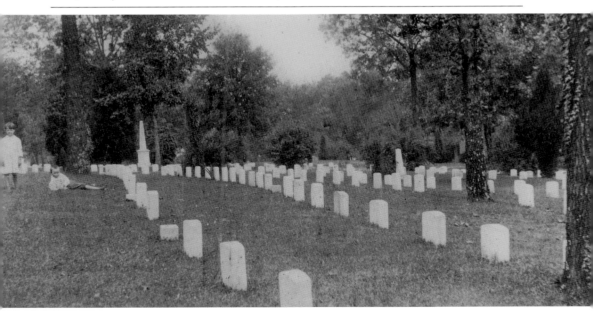

Marietta's population quadrupled during World War II, and the number of churches increased as well. With space at a premium, what is now Roswell Street Baptist Church began meeting at the antebellum Roberson Plantation on Roswell Street, seen here in a picture from the 1930s. The old house made way for a succession of sanctuaries through the years, the latest of which are shown here. (Then image courtesy of Marietta Museum of History.)

ROSWELL, WASHINGTON, AND LAWRENCE

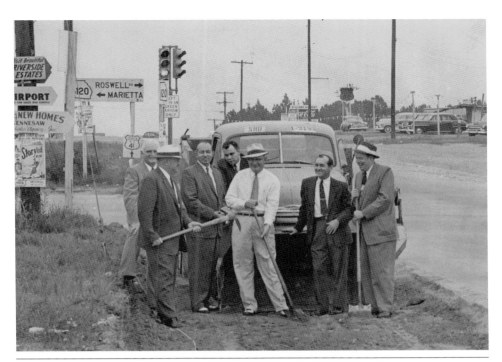

The Business and Public Affairs Committee of the Marietta Kiwanis Club posed in 1956 after obtaining funding for a turn lane at the Roswell Street/U.S. 41 intersection. From left to right are Lockheed president Carl Kotchian, Judge Jim Manning, Claude Hicks, the *Marietta Daily Journal*'s Bill Kinney, Emmett Hobbs, Bill Hardy, and state senator Harold Willingham. In the years since then, Kinney has achieved local landmark status, just like the Big Chicken KFC across the street. (Then image courtesy of Marietta Museum of History.)

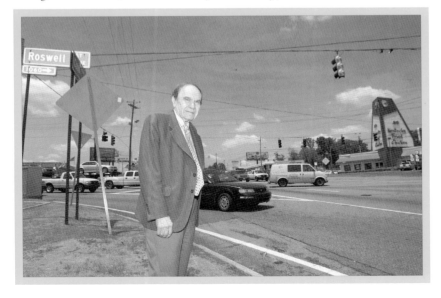

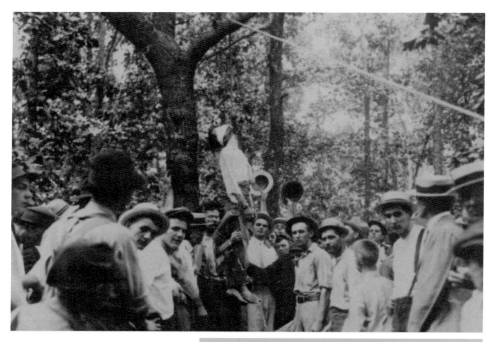

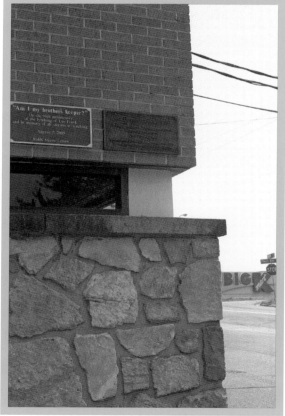

When the death sentence handed to Atlanta Pencil Factory manager Leo Frank was reduced to life for the murder of 13-year-old "Little Mary" Phagan in 1915, Mariettans kidnapped Frank from prison and carried out the original sentence in a grove along Frey's Gin Road off Roswell Road. A crowd of thousands soon gathered at the lurid scene. These plaques mark the spot today, a stone's throw from Interstate 75. (Then image courtesy of Marietta Museum of History.)

ROSWELL, WASHINGTON, AND LAWRENCE

The events of four decades earlier still seemed to haunt the grove near Frey's Gin when this moody picture was taken in the 1950s looking toward Cobb Parkway. The area has been better known since the 1960s as the home of "The Big Chicken," the world's most unusual KFC restaurant, seen here in the distance. (Then image courtesy of Bill Kinney Collection/Joe McTyre.)

This panoramic view of downtown was taken early in the 20th century from the Emerson Hill area. Dominating the skyline from left to right are the old First Methodist Church steeple, the smokestack from the Marietta Paper Mill, the courthouse, and the First Baptist steeple. The pond in the foreground is long gone, as is obvious in a recent photograph taken from a construction crane at almost the same spot. In the left foreground is the roof of the main Cobb/Marietta Library. (Then image courtesy of Marietta Museum of History; now image courtesy of *Marietta Daily Journal*.)

CHAPTER

FAIRGROUND STREET

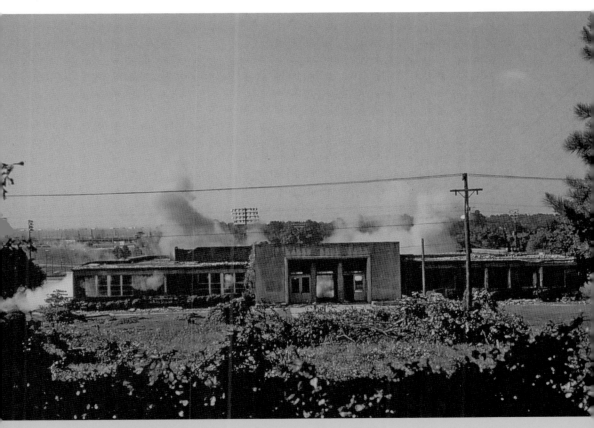

After the Larry Bell Center at Fairground and Clay Streets burned in the mid-1960s, the remains of that recreation center/bowling alley (which even earlier was the site of the old county work farm, where chain-gang prisoners were housed) were imploded to make way for the Cobb Civic Center. (Courtesy of Ernest Wester Collection, Kennesaw State University Archives.)

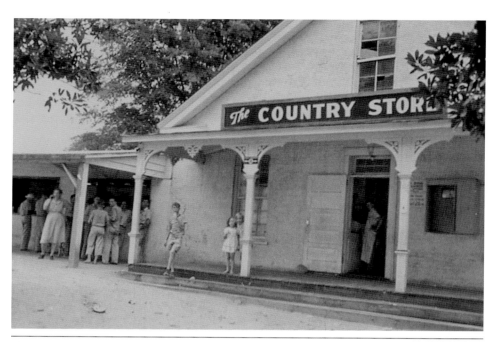

This rustic-looking grocery was just down the hill from the Bell Aircraft plant, where hundreds of B-29 Super Fortress bombers were being assembled when this shot was taken during the early 1940s. The Country Store served plant workers and residents of the 1,000-unit Marietta Place public housing development, where the Lockheed Credit Union and an office park now stand. (Then image courtesy of Bill Kinney.)

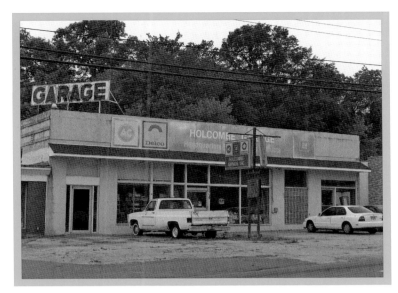

The Bell Service Station and Garage pumped plenty of gas for workers up the hill at the nearby Bell Aircraft plant, even with World War II gas rationing in effect. And with office space at a premium in town, it also served as the office for attorney Leonard Herndon. Nearly 70 years later, the gas station has fallen on hard times and would be unrecognizable if not for the glass bricks at right. (Then image courtesy of Bill Kinney.)

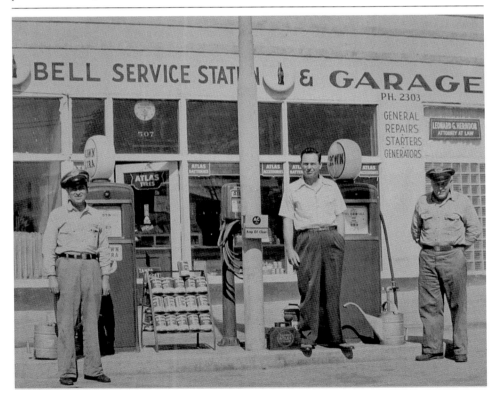

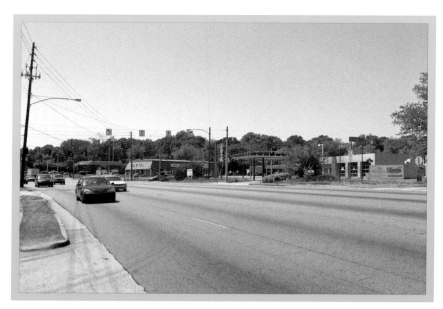

One of Marietta's first "suburban" shopping areas, the intersection of Clay and Fairground Streets down the hill from the Bell plant featured the Bell Theatre at right plus Dunaway Drugs and a Kroger supermarket across the street. Note the weeds growing on the median in foreground. Today the Fairground/South Loop intersection, though nondescript, is one of the busiest in town. (Then image courtesy of Bill Kinney.)

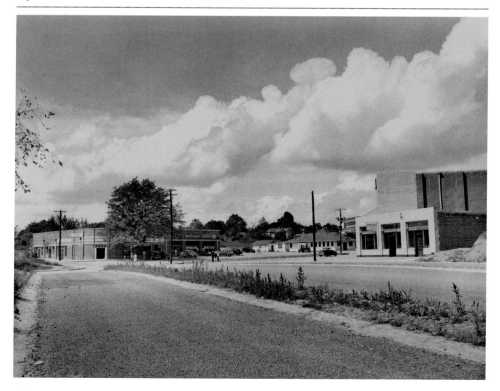

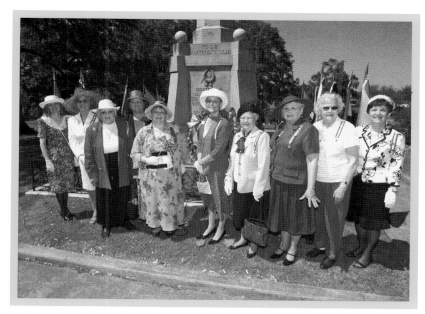

The honored guest at the 1908 ceremony dedicating the obelisk at the Confederate Cemetery was Gen. Clement Evans, left, who survived nine battles and five wounds under Gen. Robert E. Lee in Virginia. Evans became a Methodist minister afterward and in 1908 was the last surviving Georgian to have been a general. Ninety-nine years later, the Kennesaw Chapter of the United Daughters of the Confederacy marked Confederate Memorial Day 2007. (Then image courtesy of Marietta Museum of History.)

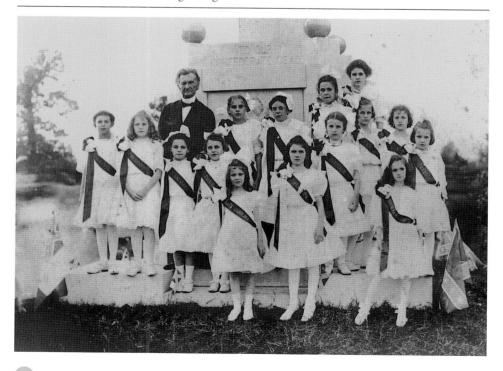

ATLANTA AND POWDER SPRINGS STREETS

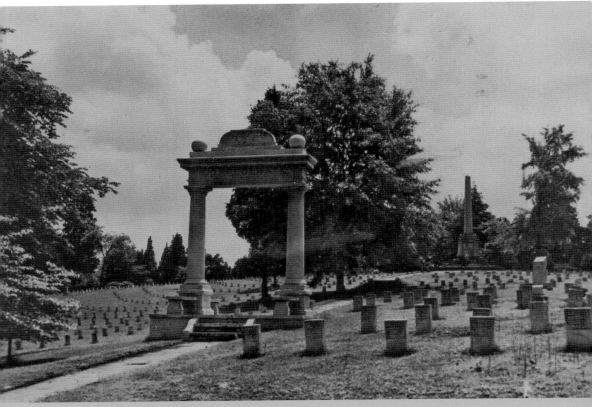

Marietta Confederate Cemetery, seen here in the 1930s, is the final resting place of more than 3,000 men in gray, most of them unknown, and is the biggest Confederate burial ground between Richmond and Atlanta. It was established on what was then the outskirts of town along Powder Springs Street in 1863. (Courtesy of Vanishing Georgia Collection, Georgia Department of Archives and History.)

Clay Street, named for late U.S. senator A. S. Clay of Marietta, looks east toward Fairground and the Bell Theatre with the soon-to-open Larry Bell Center at right. Clay Street was widened and incorporated into South Marietta Parkway in the 1970s, and the Bell Center was replaced with the Cobb Civic Center at right. The embankment at left in the 1945 picture is long gone. (Then image courtesy of Bill Kinney.)

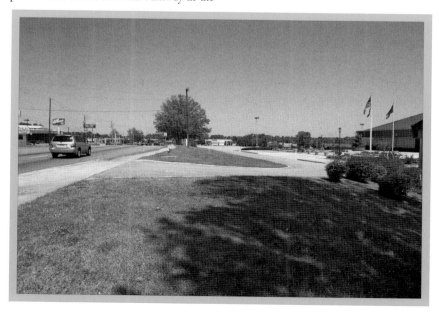

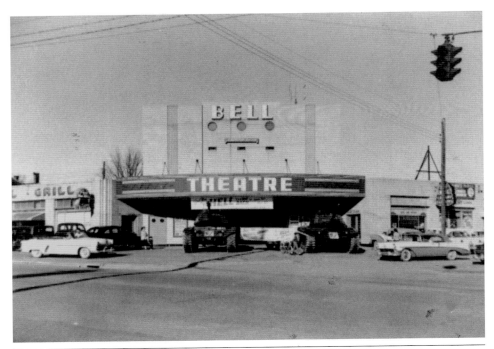

The art deco Larry Bell Theatre stood just down the hill from the Bell Aircraft plant at the corner of Fairground and Clay Streets at what today is the corner of Fairground and South Marietta Parkway. Note the pair of tanks parked out front for the local premiere of World War II hero Audie Murphy's 1955 biopic, *To Hell and Back*. (Then image courtesy of Bill Kinney.)

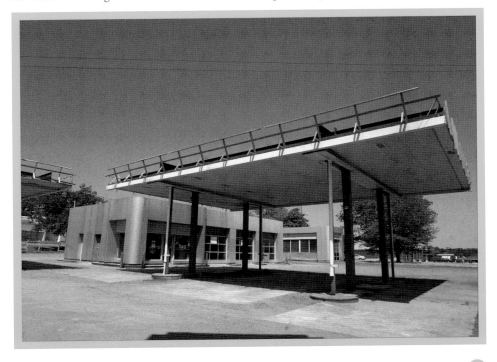

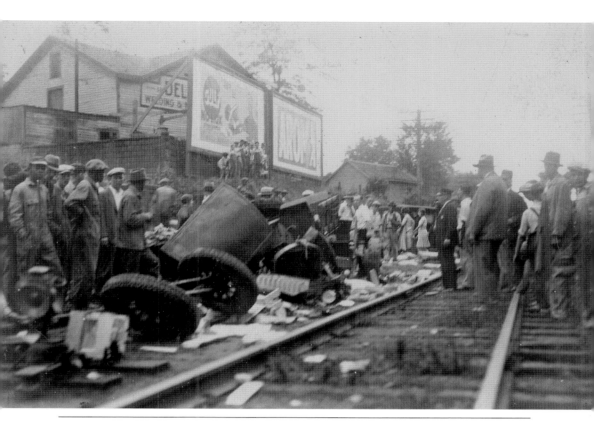

Marietta sits astride one of the busiest freight-rail lines in the country, which has made for a steady diet of car-train collisions through the years, such as this one in mid-1938 at the Powder Springs Street crossing, just a few feet from where today stand a Wendy's and Church's Fried Chicken. (Then image courtesy of Bill Kinney.)

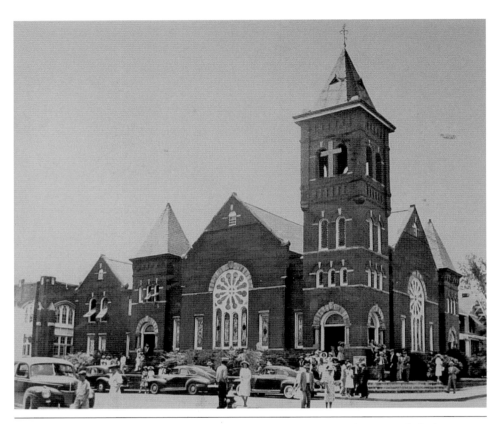

The Marietta skyline was dominated for 75 years by the steeples of the courthouse and of First United Methodist Church a block away at the corner of Atlanta and Anderson Streets, seen here. The congregation dedicated this sanctuary in 1900 and moved to its present home on Whitlock Avenue in 1966. The old sanctuary was demolished but the Education Building remains, now the law offices of former governor Roy Barnes. (Then image courtesy of Marietta Museum of History.)

The 1910 Atlanta Street building at right served at various times as an opera house, Masonic Lodge, and armory and was just down the street from the square and the post office. Then in 1927, it was put into use as city hall until construction of the present structure on Lawrence Street in 1979. (Then image courtesy of Marietta Museum of History.)

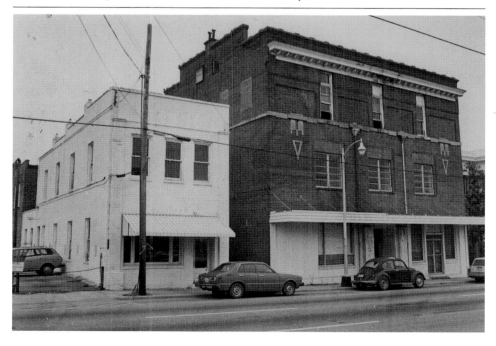

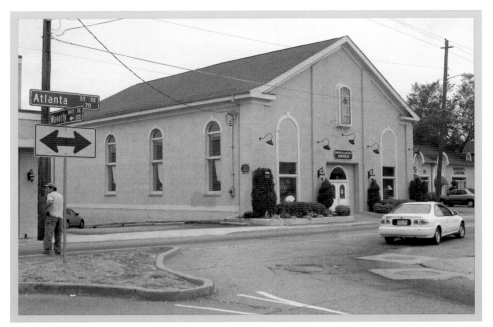

Marietta Methodists first met in a log cabin roughly at the site of their present church on Whitlock Avenue before building this sanctuary on Atlanta Street in 1849. It later was sold to the St. Joseph's Catholic congregation and after that was used as an auto-repair garage. Seen here in 1984, the restored building now is home to Marietta Lighting. (Then image courtesy of Dr. Tom Scott.)

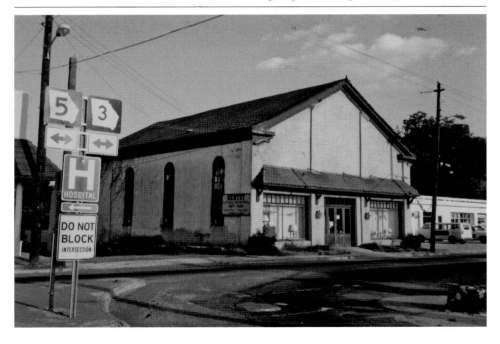

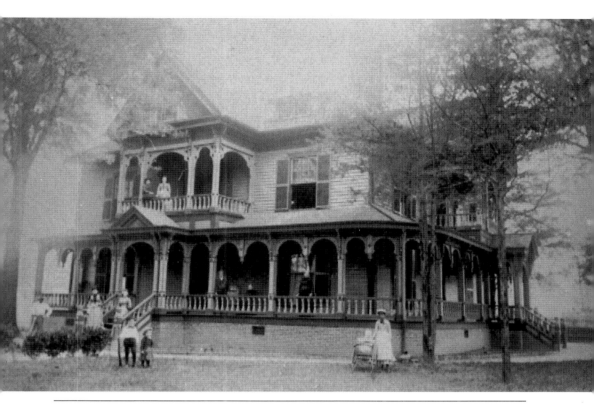

George W. Winters opened the first tavern in Marietta on the south side of the square in 1833. His son, banker and businessman John Winters, built this mansion on Winters Street at Waverly Way facing the square two blocks north. The Winters House later became the Marietta Elks Lodge, and what once was one of Marietta's prettiest Victorian houses is now one of its most barren parking lots. (Then image courtesy of Marietta Museum of History.)

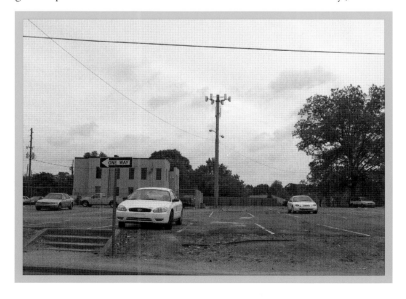

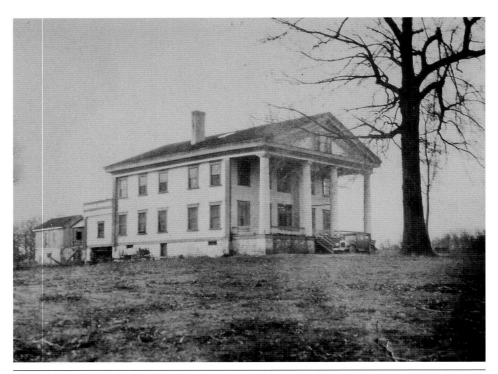

Marietta's first mayor, John Heyward Glover, built this Greek Revival mansion, Bushy Park, in 1848 just west of the railroad south of town. It was purchased in the 1990s by another Marietta mayor, Bill Dunaway, who operated it as the 1848 House Restaurant before closing it in 2003 and selling the surrounding property for a condominium development. The mansion in 2007 was surrounded by a chain-link fence. (Then image courtesy of Marietta Museum of History.)

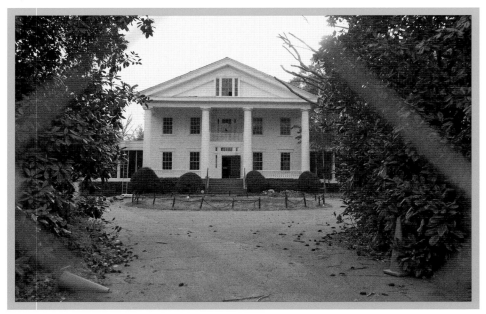

WHITLOCK AND KENNESAW AVENUES AND POLK STREET

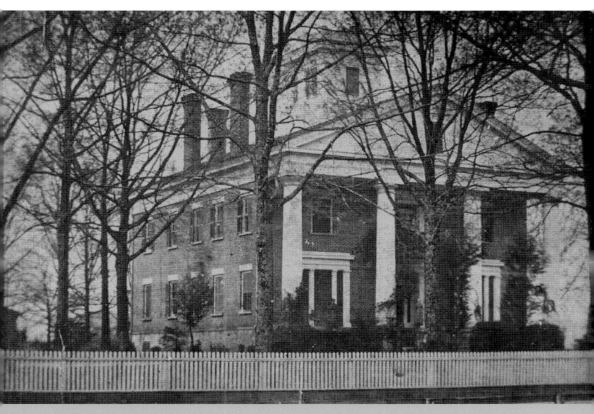

Archibald Howell built this Greek Revival–style house on Kennesaw Avenue in 1848, featuring columns that are 11 feet in diameter and said to be the largest in Georgia. It was briefly used as a headquarters by Union general H. M. Judah when in command of north Georgia early during Reconstruction. (Then image courtesy of Marietta Museum of History.)

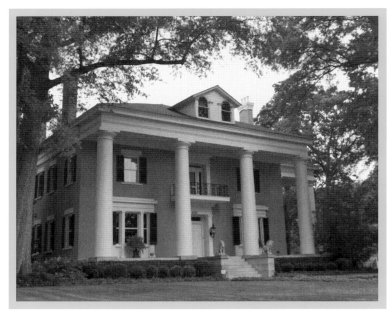

In 1887, the Howell house became the Harwood Seminary, an academy for the daughters of the town's elite. Later owner William Sessions undertook major changes after buying it in the 1890s, adding a massive porte cochere (a covered entrance for carriages), covering its bricks with stucco, removing its Greek temple-style pediment, and converting its widow's walk to a dormer. Its exterior has changed very little in more than a century. (Then image courtesy of Marietta Museum of History.)

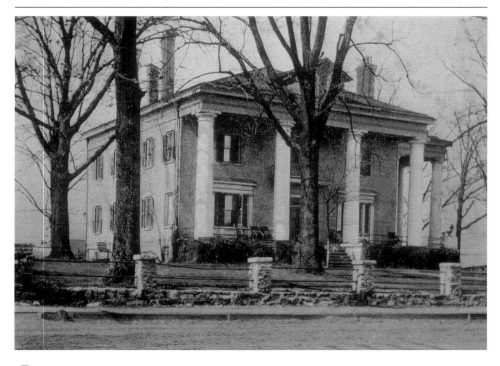

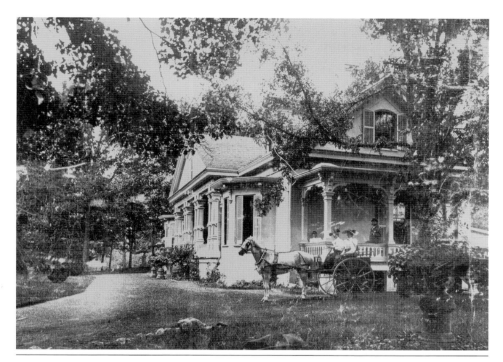

Built in 1838, Oakton on Kennesaw Avenue was originally a four-room Greek Revival house and the headquarters during the Battle of Kennesaw Mountain of Confederate general William W. Loring. It later was expanded and given a Victorian facade, as noted in this picture from the turn of the century. Seen here is present owner Will Goodman, whose family purchased the home in the 1930s and has restored it and its expansive gardens. (Then image courtesy of Marietta Museum of History.)

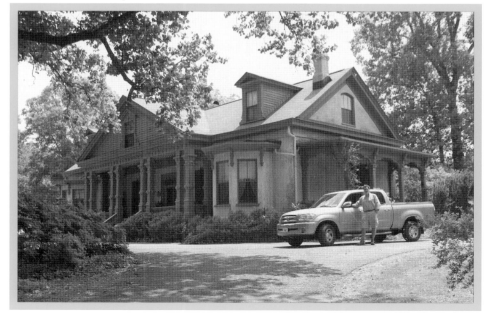

The Marietta High Blue Devils football team played at Brown's Park next to today's Northcutt Stadium for nearly two decades before the latter's opening in 1940, as evidenced by this photograph from 1937. Games back then took place on what today is a parking lot adjacent to the stadium. Marietta High School games still take place at Northcutt, even though Marietta High has moved to Whitlock Avenue. (Then image courtesy of Marietta Museum of History/Jabez Galt; now image courtesy of *Marietta Daily Journal*/Damien A. Guarnieri.)

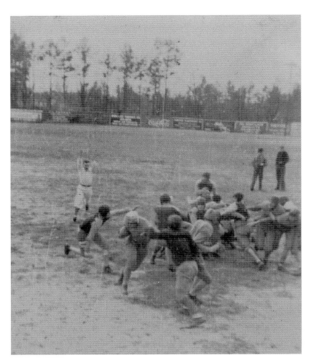

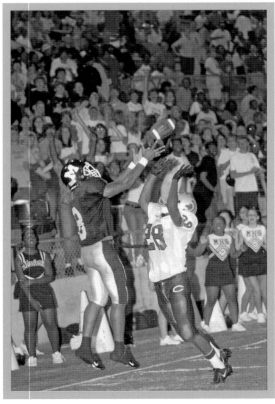

The Aymar and Judy Manning house, seen here in the 1970s, stood hidden behind a thick screen of trees on Whitlock Avenue for well more than a century. Built by a Manning family member just after the Civil War, it was demolished in 2006 to make way for the Burnt Hickory Plaza strip center. (Then image courtesy of *Marietta Daily Journal*.)

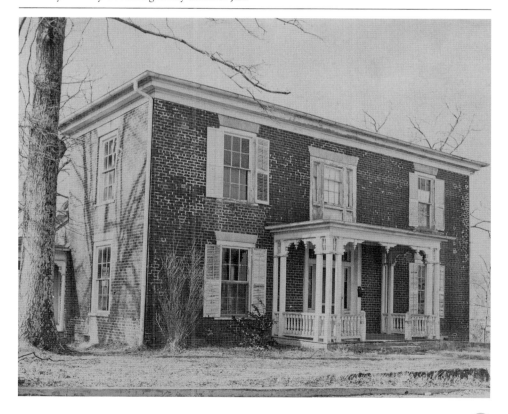

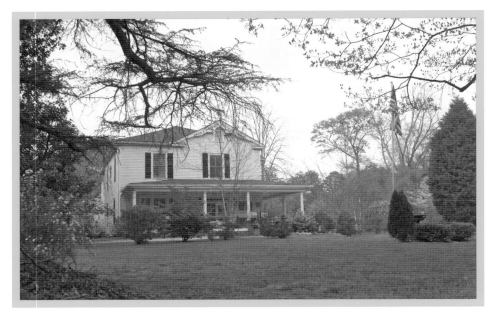

This house was built in 1887 by the Metcalf family on Whitlock Avenue. Seen here in the late 1920s or early 1930s, it was home to vagrants by the mid-1990s and in danger of being demolished. But fortunately, it underwent a $225,000 renovation at the hands of new owners Rob and Marcia McClure with the help of the nonprofit Cobb Preservation Foundation and the Georgia Trust for Historic Preservation. (Then image courtesy of Marietta Museum of History.)

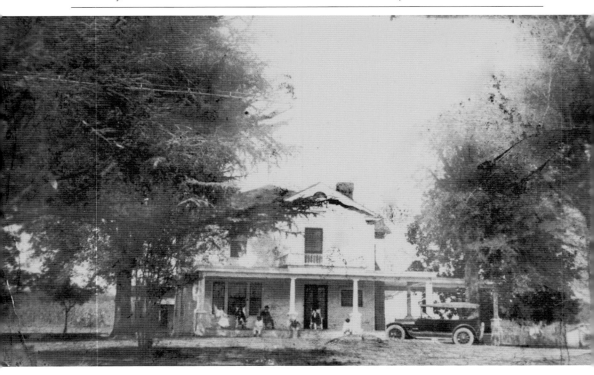

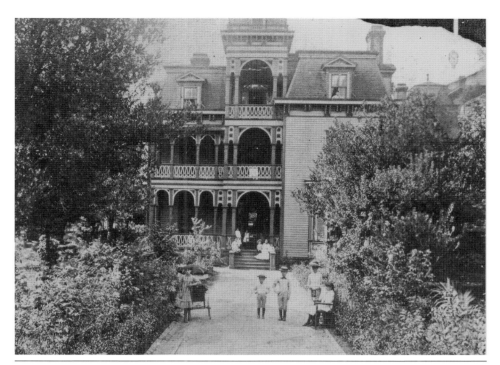

The 104-room Whitlock House, built by Milledge G. Whitlock, was the biggest hotel in town during the post–Civil War period and was a hub of Marietta's social life for decades until it burned down in April 1889. The antebellum house eventually was replaced by these two spacious homes and a bank next door (not shown). Keeping faith at left with its predecessor is the Whitlock Inn bed-and-breakfast. (Then image courtesy of Vanishing Georgia Collection, Georgia Department of Archives and History.)

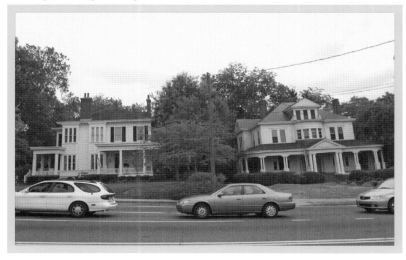

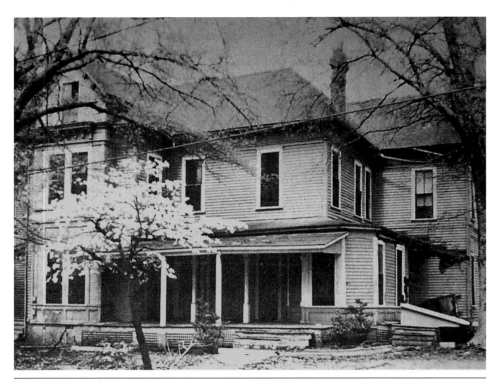

Marietta's first true hospital, seen here, was built about 1920 on Whitlock Avenue, and among those born there was future *Marietta Daily Journal* editor Bill Kinney. It later was converted to a boardinghouse known as the Locust Lodge after a new hospital opened in 1950 on Cherokee Street. The lot now is occupied by BellSouth. (Then image courtesy of Bill Kinney.)

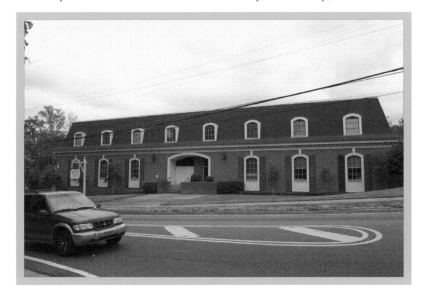

These two youngsters are peddling "prepackaged" kindling wood—a necessity in the era of potbellied stoves for cooking and heating. This shot was taken on Wright Street looking toward Whitlock Avenue. Behind them in the distance is the Legg House, built in the 1880s and demolished—after some controversy—in 1996. At the edge of the picture at right is the balcony of the Whitlock House hotel, which burned in 1889. (Then image courtesy of Vanishing Georgia Collection, Georgia Department of Archives and History.)

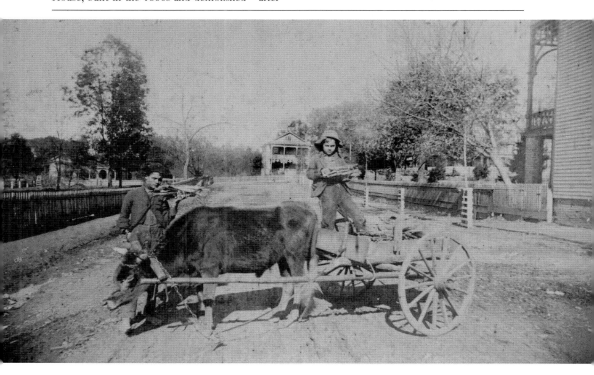

Discover Thousands of Local History Books Featuring Millions of Vintage Images

Arcadia Publishing, the leading local history publisher in the United States, is committed to making history accessible and meaningful through publishing books that celebrate and preserve the heritage of America's people and places.

Find more books like this at
www.arcadiapublishing.com

Search for your hometown history, your old stomping grounds, and even your favorite sports team.

Consistent with our mission to preserve history on a local level, this book was printed in South Carolina on American-made paper and manufactured entirely in the United States. Products carrying the accredited Forest Stewardship Council (FSC) label are printed on 100 percent FSC-certified paper.